Release Your
Creativity

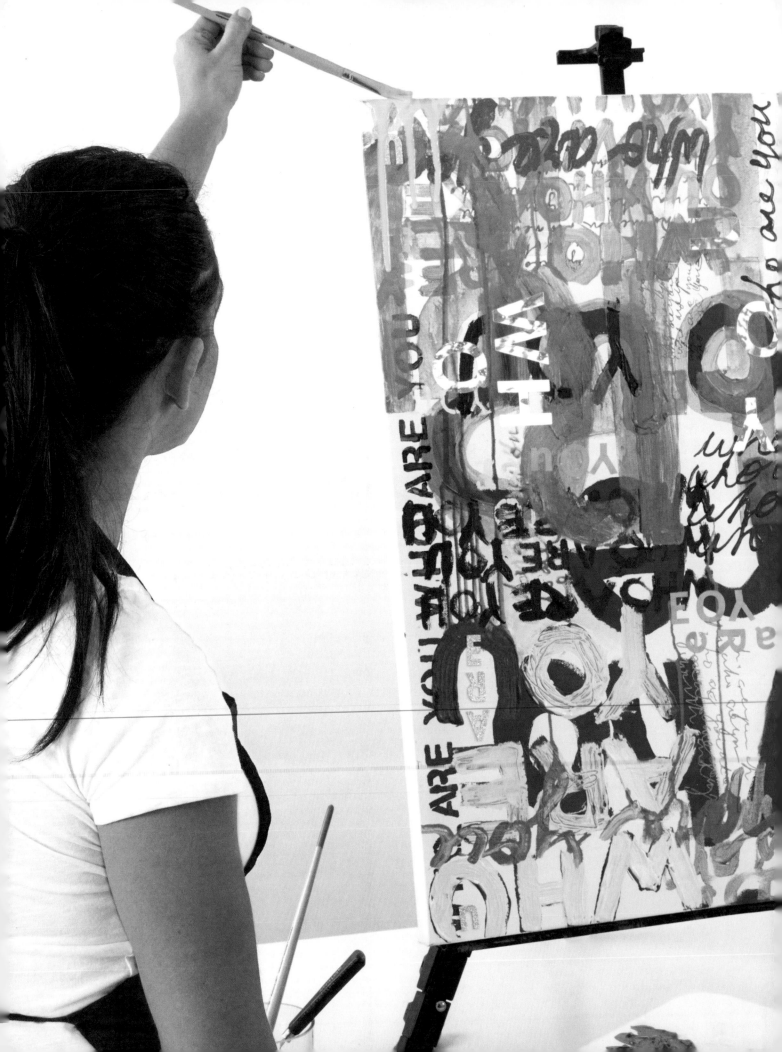

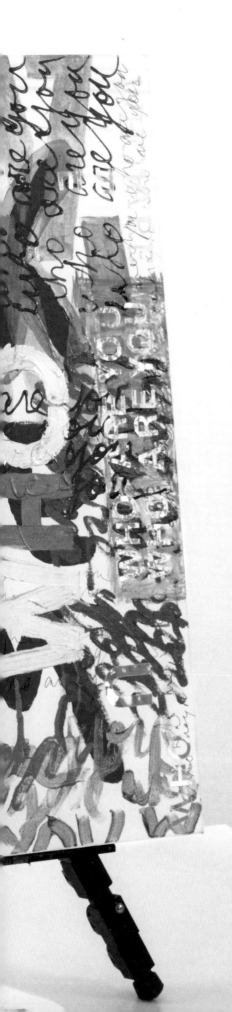

Release Your Creativity

Discover Your Inner Artist with
15 Simple Painting Projects

Rebecca Schweiger

 Get Creative 6

DEDICATION

To three generations of family
who have blessed me with
both roots and wings:
My grandparents, Beatrice and Harold
My mom, Ingrid
My nephews and niece, Alex, Jacob, and Emily

Library of Congress Cataloging-in-Publication Data

Names: Schweiger, Rebecca, author.
Title: Release your creativity : discover your inner artist with 15 simple
 projects / by Rebecca Schweiger.
Description: First Edition. | New York : Get Creative 6, 2017. | Includes
 index.
Identifiers: LCCN 2016034307 | ISBN 9781942021483 (pbk.)
Subjects: LCSH: Art--Technique. | Creative ability--Problems, exercises, etc.
Classification: LCC N7430.5 S39 2017 | DDC 751.4--dc23
LC record available at https://lccn.loc.gov/201603430

Manufactured in China

1 3 5 7 9 10 8 6 4 2

First Edition

Contents

Introduction

*"The desire to create is one of the deepest
yearnings of the human soul."*
—DIETER F. UCHTDORF

In our fast-paced, achievement-focused, and electronically driven world, I believe we are facing a crisis of physical burnout, emotional emptiness, and spiritual starvation. We are neglecting our own happiness and dreams, and we have lost touch with how to live meaningful, fulfilling lives. In this chaotic and overwhelming environment, we have forgotten how to care for our souls.

While creativity can be a wonderful antidote to so many of these modern problems, myths about what art is and how an artist creates keep many people away from something that would bring them great benefit: the power of creative self-expression. I often find people who think, "I am not artistic" or "I do not have a creative bone in my body." Many first-timers who come to my art studio believe they are lacking talent and are fearful they will make fools of themselves when they create a piece of art. Some do not even believe that what they will create is actually art.

However, I believe we are all born with the need to express ourselves, and that it is time for a creative revolution. Creativity is accessible to everyone, including you. You are creative, you just might not know it yet! In this book, I will show you how to develop your creativity through fun, easy projects with beautiful results. As you learn about the tools you need and undertake the projects included here, you can also achieve the personal fulfillment, stress-relief, and

increased well-being that many people feel when they create art.

As a child navigating the waters of my parents' tumultuous divorce, I desperately needed a safe outlet to express myself. Creativity became both my compass and anchor in times of trouble and celebration alike. Approaching early adulthood, I faced unexpected, severe anxiety that became a source of frustration, failure, unhappiness, and intense stress. Throughout my recovery, creativity uplifted me while providing the much-needed stability and sense of purpose that I longed for when I felt despair, fear, and loneliness.

Later, after I graduated from university, I understood how artistic expression had transformed my own life, and I felt passionate about spreading the power of creativity to as many other people as possible. I began teaching my own unique, hands-on method of artistic self-expression in a variety of untraditional settings. From a facility for behaviorally challenged teens to nursing homes with residents who were facing the ends of their lives, I found no place or circumstance prevents creativity. It is an elixir that soothes the soul and awakens the joy of the young and old, and the troubled and calm. For me, what started as survival grew into a way to encourage others. It then became my life's work when I founded The Art Studio NY with the mission to empower people to unleash their creative lives.

This book is the result of years of teaching at my studio and leading creativity workshops for students of all ages and backrounds. In these pages, I'll walk you through fear-free step-by-step art projects that you can create in the comfort of your own home that will empower you to release your creativity. Creativity that will not only enable you to create beautiful artworks, but that can sustain you as you paint the canvas of your life.

—Rebecca Schweiger

Making the Most of This Book

Soon you'll be ready to jump right in to creating beatiful works of art that reflect your own creative nature. To do that, there are myriad art supplies you can enjoy and use as you connect with your inner artist. You may already have some of these, and it's certainly not necessary to purchase all of them. I describe many of the common tools below so you can learn about the wide variety and understand the tools you'll use to express yourself in your artwork.

PAINTBRUSH TYPES

The paintbrush is the most common tool you'll use to bring color onto your canvas and into your world. Paintbrushes come in a variety of shapes and sizes, and each, through the different way it applies paint, creates its own texture and line.

Each type of paintbrush is intended for specific techniques. However, my rule of thumb is this: experiment, try it on for size, and see what you like the most. Find the paintbrushes that you love to paint with.

Play with an array of brushes, and discover your own personal favorites that feel good in your hand and allow you to fully express your heart. Since variety is the spice of life, having a mix of paintbrushes will allow you to more fully enjoy your painting experience while communicating your inner world artistically.

Flat: With its square top, the flat brush is perfect for making expressive, bold strokes. The bristles can scoop up thick paint, allowing you to apply very textured paint into your artwork. With

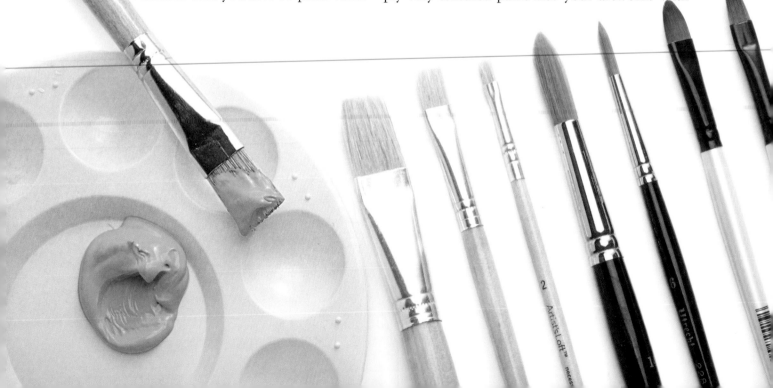

its flat, straight line of bristles, the flat also allows you to paint finer lines and crisp edges. Larger flat brushes are perfect for applying a "wash"—the first layer of paint applied onto your canvas.

Round: Round-tipped brushes are ideal for outlining, creating finer details, painting with great control, and "sketching" your composition. Depending on how hard you push down on your brush, rounds can create both thin as well as thick lines and brushstrokes. When you apply very gentle pressure and barely press down on your round paintbrush, you can create thin lines and incredible amounts of detail.

Filbert: These popular brushes are the marriage between flat and round brushes. Filberts have medium to long bristles with oval-shaped tips, and they are a great choice for applying paint in a flexible, fluid brushstroke. The perfect brushes for blending paint, they are also excellent for creating rounded edges.

Bright: Known for their flat head of short bristles, these brushes have slightly curved edges pointing inward at the tip. Brights are ideal for thick, expressive paint application. Artists who enjoy energetic, abstract brushstrokes or heavily applied paint rely on these paintbrushes often.

Angle: When you imagine a flat-tipped paintbrush with a 45° haircut, you will understand what an angle brush looks like. With its head of bristles offering the perfect angle, this paintbrush is your go-to tool for defining lines, corners, and edges or delineating a wide variety of shapes.

Fan: With its long, flat hairs that are spread out in the shape of a fan, this brush is terrific for soft blending, smoothing paint, and creating a feathered paint appearance. Fan brushes create beautiful effects in landscape paintings, especially when painting skies, trees, clouds, or anything with a sense of lightness or motion.

Pointed round and detailed round: A close relative to the round brush, the pointed round is narrower and pointed at its tip. The detail round is similar to the pointed round, however it has even shorter bristles and a shorter angle at its tip. Both are excellent choices when you want to add fine details or delicate paint applications.

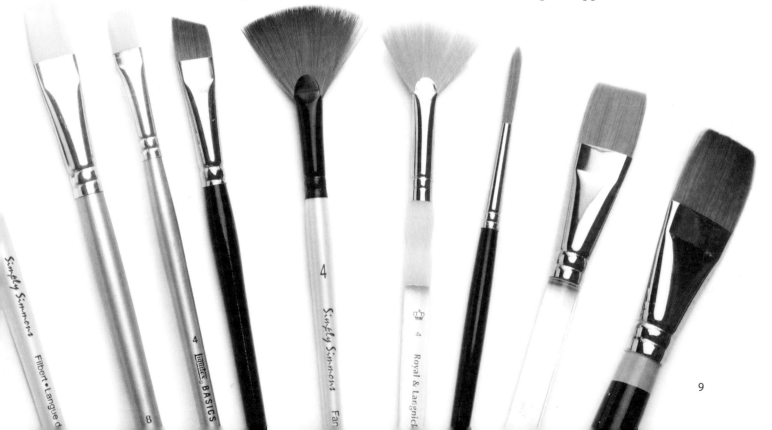

Sizes: Paintbrushes come in every size under the rainbow. Their sizes vary from brand to brand, so the number scale is not consistent from one brand to another. Instead of being overly concerned with the sizes on the packaging, choose brushes that you enjoy holding in your hand. In this book, we will use the words *small*, *medium*, and *large* to identify brush sizes. Imagine small paintbrushes as being used for specific or intricate details. These will often be very thin, round brushes or smaller-tipped flat brushes. Your medium and large brushes will often be flat brushes that are anywhere from ¼" thick to 1" thick. Use your intuition and choose brushes that you feel excited to paint with.

Foam dabbers: With their wooden or plastic handle and sturdy foam head, these are the ideal partner to use alongside stencils. Foam dabbers are also great for creating repetitive shapes and patterns in your artwork.

Palette knife: Perfect for both mixing and applying your paint, these metal or plastic knives come in a variety of sizes and shapes. To preserve their paintbrushes, many artists prefer to use palette knives to mix paint colors. Palette knives

are ideal for thick and heavy paint application as well as creating expressive, textured marks, shapes, and layers of paint. You may also use the tip of your knife to scrape into wet paint, or use the side of your knife to scrape away wet paint, so that the previous layers of paint will be visible.

MORE ON PAINTBRUSHES

What to buy: When starting out, you do not need a lot of paintbrushes! Many art stores sell affordable (in the $20 range) beginner sets of paintbrushes with four to six brushes. Make sure that your kit includes two flat brushes of varying widths and two round brushes of differing sizes. Experiment and find the style of brush you like the most. Once you are more familiar with paintbrushes, you can begin to acquire more brushes to add to your painting toolkit.

How to choose brushes: Do your best to purchase brushes that do not "shed" or have overly tough bristles, as the stray hairs can get stuck in your artwork. I suggest synthetic over natural hair brushes. Made from polyester, they create beautiful textures, and they do not harm animals.

How to care for your brushes: If you take good care of your paintbrushes, they can last for many years. Never, ever let paint dry into your paintbrushes. If you do, your brush will turn into a useless stick and quickly find its way into the garbage can! Ideally, when using your brushes, after you finish using one color, swish your brush around in water immediately, and dry it off with a rag before moving on to the next color. Try not to leave your brushes, bristles down, in water for too long, as they could lose their shape. We all love a bit of TLC, and so do your brushes. Once or twice a year, I soak my brushes in Murphy's Oil overnight, and then I thoroughly clean them the next morning. This reconditions the brushes and leaves them looking and feeling like new.

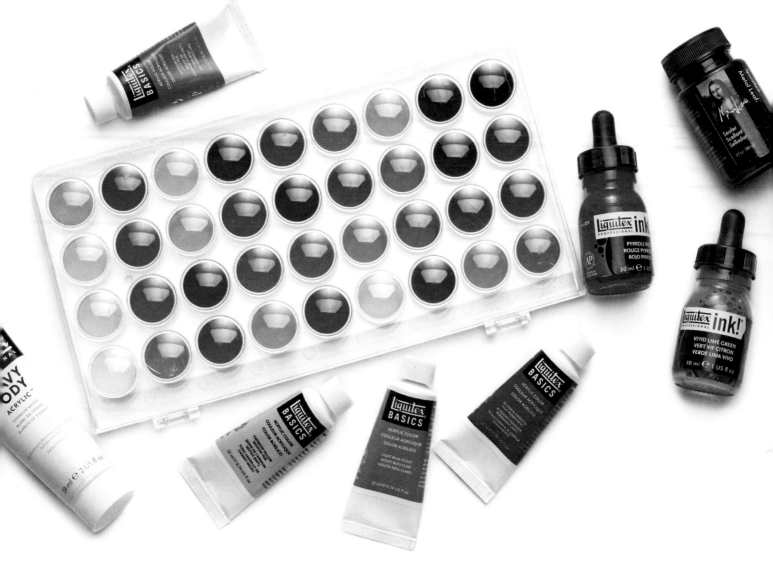

How to clean your brushes: It is critical to thoroughly clean your brushes after every use. If you do not, you will quickly ruin your paintbrushes. Follow these steps for happy, healthy brushes:

1. Generously swish your brushes around in water, and tap off the excess water before wiping each one with a rag.

2. Repeat this step at least twice.

3. At your sink, rinse your brushes in warm running water and allow any excess paint to be rinsed off.

4. Now, with either dish soap, a bar of hand soap, or special artist's paintbrush soap, gently massage the soap onto and into the bristles of your brush. I often hold my brushes in one hand while I create a swirling motion into the soap I am holding in my other hand.

5. As you rinse off the soap under water, see if any paint color is being removed. If so, repeat steps 4–5 until no color comes off your brush.

6. Once your brush is clean, gently wipe off with a clean rag, and reshape the bristles with your fingers. Lay flat and allow to dry.

Notice that the only time your brush will be perfectly clean is before you use it! Your bristles will become tinted with color, and the handle will become covered with paint. This is normal, and is a sign that you are enjoying painting.

PAINTS

Acrylic paint: Water-based, non-toxic and odorless, acrylic paints are versatile, easy to use, and perfect for beginners and seasoned artists alike. Acrylic paints come in a wide variety of colors

and have a vibrant appearance, interesting textures, and are a great choice for painting a range of self-expressive artworks. They dry quickly and are easy to layer. Quite forgiving, it is easy to paint over mistakes and make changes when painting with acrylic paint. While acrylics share a similar appearance to oil paints, acrylics are much safer and easier to use. From realism to abstraction and landscapes to portraits, acrylics are perfect for painting any type of subject matter in any style of your choice. They also are a great choice of paint to accompany a range of mixed-media and collage projects.

My favorite brand of acrylic paint is Utrecht Studio Series. An eight-ounce tube is about five dollars, and they make kits with an array of basic colors as well. These paints are thick, brightly colored, and similar to higher priced acrylics.

Watercolor paint: If you enjoy artwork with a soft, delicate, and translucent appearance, watercolor paints are the perfect choice for you. With their rich pigments and wide variety of available colors, watercolor paints are readily mixed with water, easily portable, odorless, and easy to both set up and clean up. Watercolors can be purchased in either small tubes or trays for use on their own or in combination with pencils, pastels, or collage. Less forgiving than acrylic paint, watercolors often require slightly more advanced planning. I suggest an academic or student-grade starter kit that offers a selection of at least eight basic colors.

Ink: This ancient art medium is a water-based, non-toxic, and odorless art material that is known for its watery, smooth texture. It is often used on drawings, illustrations, paintings, and mixed-media artworks. Available in individualized small bottles with their own droppers, inks are richly pigmented colors that are vibrant, fluid, typically inexpensive, and easy to use. Similar to water-color paint, yet often offering a brighter punch of color, inks are an expressive art material used to create splatters, drips, lines, and smaller paintings. When water is added to ink, a variation of color tones may be created. Acrylic inks are extremely fluid acrylic paints that are available in opaque and metallic colors.

ACRYLIC MEDIUMS

To fully express your inner artist, acrylic mediums allow you to alter the effect of acrylic paint. Whether you want to make your paint thicker, thinner, glossier, or more matte, a variety of mediums are available for your creative exploration. To change the actual texture of your paints, the following examples of textured mediums are exciting to explore and further expand the possibilities for self-expression.

Molding paste: A heavy, thick white paste that may be molded to create a variety of three-dimensional textures in your artwork.

Crackle paste: A white paste that, when dry, produces cracks similar to those found on very old plaster. The effect is reminiscent of the walls of an ancient chapel or villa.

Pumice medium: This thickly textured, grainy medium has the consistency of course sand to lend texture to a work.

Clear tar gel: A white stringy material that dries clear and, when added to paint, can enhance the dripping or splattering effect.

Acrylic paint retarder: A medium that, when mixed into acrylic paint on your palette, extends the drying time of the paint, enhancing your ability to mix paints on your palette and blend paint in your artwork for a longer period of time.

OTHER MEDIUMS

Oil pastels: Available in brightly colored sticks of pigment, oil pastels are a bridge between draw-

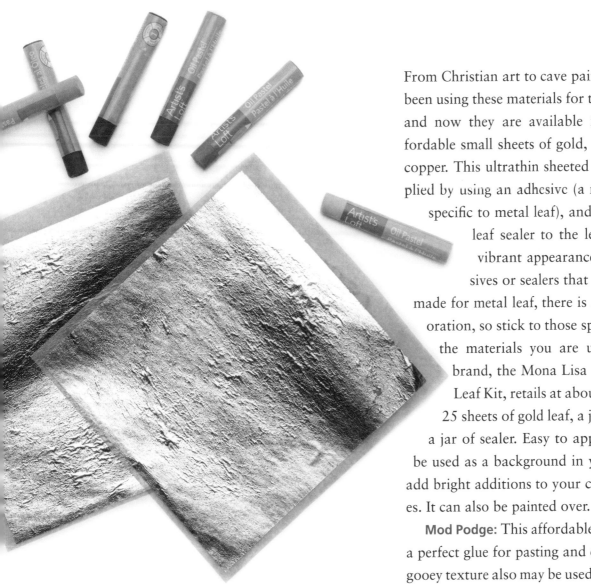

From Christian art to cave paintings, artists have been using these materials for thousands of years, and now they are available in easy-to-use, affordable small sheets of gold, silver, bronze, and copper. This ultrathin sheeted art material is applied by using an adhesive (a milky looking glue specific to metal leaf), and it is best to add a leaf sealer to the leaf to maintain its vibrant appearance. If you use adhesives or sealers that are not specifically made for metal leaf, there is a chance of discoloration, so stick to those specifically made for the materials you are using. My favorite brand, the Mona Lisa Composition Gold Leaf Kit, retails at about $12 and includes 25 sheets of gold leaf, a jar of adhesive, and a jar of sealer. Easy to apply, metal leaf may be used as a background in your artwork or to add bright additions to your creative masterpieces. It can also be painted over.

Mod Podge: This affordable, glossy adhesive is a perfect glue for pasting and collaging. Its thick, gooey texture also may be used to provide a glossy finish to any of your artwork. While it is white in the jar, it dries clear. You may apply it with a paintbrush or with your fingers, and it washes off easily. Mod Podge does have a distinctive odor, so if you are sensitive to smells, you may want to skip it or work in a well-ventilated area.

Acrylic gloss medium and varnish: This milky white, thin liquid gloss dries completely clear and is ideal for making acrylic paints glossy. This material has a variety of uses, and it is a staple that I turn to often. Used in collage and mixed-media artwork as an adhesive, it is perfect for gluing seamlessly when you want a clean, flat appearance in your artwork. Because acrylic paint has a tendency to look glossy when it is wet yet appear matte when it is dry, I often apply this medium as a final layer to my acrylic paintings to brighten

ing and painting. Perfect for expressive drawing, they may also be used on canvas or paper with acrylic paint, watercolor paint, or with collage and mixed-media projects. Oil pastels are perfect for those who enjoy blending colors together, and layers of color may be applied. If you apply watercolors on top of oil pastels, the oil pastels will show through to create a fun and interesting visual technique called "wax resist." With oil pastels, you do get what you pay for. The more expensive brands offer brighter colors, creamier textures, and easier blending.

Gold leaf, metal leaf, adhesives, and leaf sealer: To achieve a luxurious radiance in your artwork, metal leaf (also referred to as gilded leaf) creates a timeless, sophisticated addition to your artwork.

the color and achieve a lasting glossiness. You may also apply this medium to an acrylic painting on top of any layers that are completely dry and then continue painting when the medium dries. Lastly, you may add this gloss into your paints on your palette to increase their level of gloss while you are creating your artwork.

SURFACES

When creating artwork, there are many surfaces to use, and while one is not better than the other, it is important to understand what each surface offers the artist. Through practice, you will learn which surfaces you enjoy the most.

Paper: This is an affordable and accessible surface for creating artwork made with ink, watercolor, drawing materials, mixed-media supplies, and acrylic paint. Not all paper is created equal. While lighter-weight paper, such as a sketchbook paper, is perfect for pencil or marker drawing, heavier paper is needed for artwork created with watercolors, inks, and acrylic paints because it is more absorbent, stronger, and less likely to warp or tear.

Watercolor paper: This type is sold in blocks, pads, or large individual sheets. When it comes to watercolors, the heavier paper is best for durability. When the paper is a heavier weight, it also absorbs pools of water more effectively. Watercolor paper is also used for collage and mixed-media artwork because of its strength.

Canvas: The most popular surface for acrylic and oil painting, canvases come in many shapes, sizes, prices, and even textures. They are typically made of cotton, but are also available in linen and even silk. Cotton canvas is the perfect surface to begin acrylic painting. Canvases are available both stretched over a wooden frame and stretched over a piece of board (with no frame). When a canvas is already framed with wood, your artwork is easy to hang right on the wall. You can create attractive effects by painting the edges of your canvas or adding gold or silver leaf to the edges themselves. When choosing a canvas, first consider what size appeals to you. For the seasoned artist, you will want to consider if you prefer a very smooth canvas versus a canvas with texture (also called tooth) to it, which will affect your entire painting experience. Student or academic grade canvases are perfect for beginners, and their prices are very affordable. I suggest experimenting with a variety of sizes and shapes to discover what you enjoy the most.

OTHER TOOLS

Pencils: Terrific tools for drawing and sketching, artist's pencils are arranged in a letter system that indicates the degree of hardness. The letter "H" means that the pencil has a harder tip and the lines created with it will be a lighter color. The letter "B" pencils have a softer tip

and create much darker marks. The letters "H" and "B" are usually followed by a number that indicates the level of intensity of color. A 6B will be darker than a 2B, and a 4H will be lighter than a 2H.

Stencils: Stencils are available in all shapes and sizes, and they are offered in decorative and fanciful shapes, letters, numbers, and recognizable objects alike. Using stencils in your artwork offers a terrific opportunity for layering, collaging, and mixed-media. They're very easy to use by simply dabbing or applying paint inside the cutout area.

Decorative paper: To add incredible colors, textures, and unique layers to your artwork, decorative papers offer a simple solution. From newspapers, handmade papers, and wallpapers to books of decorative papers available at your local art supply store, the intricate, patterned, and colorful decorative papers add a dimension to your artwork that otherwise would not be available through paint and paintbrush.

Palettes: The paints you will eventually apply to your work will first be added to your palette, and there are a variety of palettes available. A wooden or plastic palette is ideal, and you may use it over and over again for many years to come. Simply squeeze your acrylic paints out of their tubes and onto your palette. When you are finished painting for the day, use your palette knife to scrape off all of the excess paint, then wipe your palette clean with a wet rag. Another great option (and one that is my personal favorite) is to purchase a piece of plexiglass from your local hardware store. (Approximately 16" x 20" is a great size to start with.) Unlike real glass, plexiglass will not break if you drop it. Apply masking tape to the rough edges to protect yourself from cuts or scratches, and tape a piece of cardboard underneath the plexiglass so that you may see the bright colors of your paint immediately. For painting on the go or for especially easy cleanup, sheets of palette paper or a box of

wax paper from your local grocery store are great options. Simply tape down a piece of wax paper, or use your palette paper straight from the pad, and throw it away once you are done painting. This less environmentally friendly choice is also less sturdy.

TIPS AND TECHNIQUES

Now that you know about the tools, here are some tips and techniques that will help you on your creative journey. Many of them are ones you'll discover and master as you explore each art project in this book.

My hands are my favorite paintbrushes: Make things interesting and explore the endless ways you can apply paint. There is no right way; find your way! An actual bristled brush is just one of many possibilities. My favorite brushes are my fingers. Perfect for blending, dabbing, or smoothing on paint, my fingers are used for painting constantly! Do not be afraid to use your hands in lieu of a paintbrush.

Choose colors that you love: As you explore color, you will learn that there are infinite color choices and combinations to use for your self expression. Experiment and use color palettes that are meaningful to you. While I use specific color choices in the projects in this book, give yourself permission to find the color palettes that are expressive of your unique personality.

Using words in artwork: Words are just one more way to express yourself creatively. Just like choosing different paint colors or using a fun, new art supply, working with words is a personal way to convey messages in your art that are meaningful to you.

Blind contour drawings: Everyone needs to warm up and stretch, and blind contour drawings offer a great way to loosen up your creative muscles. While looking at the outer edges of an object in front of you, quickly draw what you see without looking down at the paper. Instead, focus fully on the beauty in front of your eyes.

ART & SOUL work exercises: To enhance your creative experience, empower yourself by mastering creativity not only on the canvas with paint but additionally—and most importantly—in your daily life. When practiced, these soul-nurturing opportunities lead you toward seeing your life as the most important masterpiece of all.

No right or wrong in art: There are no strict rules and regulations to creating art. The most important thing to remember is to be honest, courageous, and free-spirited with your creative expression. Art welcomes every part of your being.

Process, not product: While it is wonderful to hang your beautiful painting on the wall, the juiciness of creativity is enjoyed most throughout the process. Do not be overly focused on what something looks like, rather put your energy into what the experience does for your soul and your emotional well-being.

Criticism and comparisons not welcomed here: Creativity is a safe zone, and there is no place for self-judgment. While your mind might pipe in now and then, remind yourself that art is a path toward nurturing your self-expression and your happiest self. Do not compare yourself to others, but rather focus on the positive experience of your own artistic journey.

There are no mistakes in art: Since creativity is very forgiving, there is no such thing as a mistake! Often, what you think is a mistake may end up becoming your favorite area of your artwork. Suspend judgment. However, do not be afraid to paint over and make changes in your artwork if you are not pleased with it.

15 Mixed-Media Projects

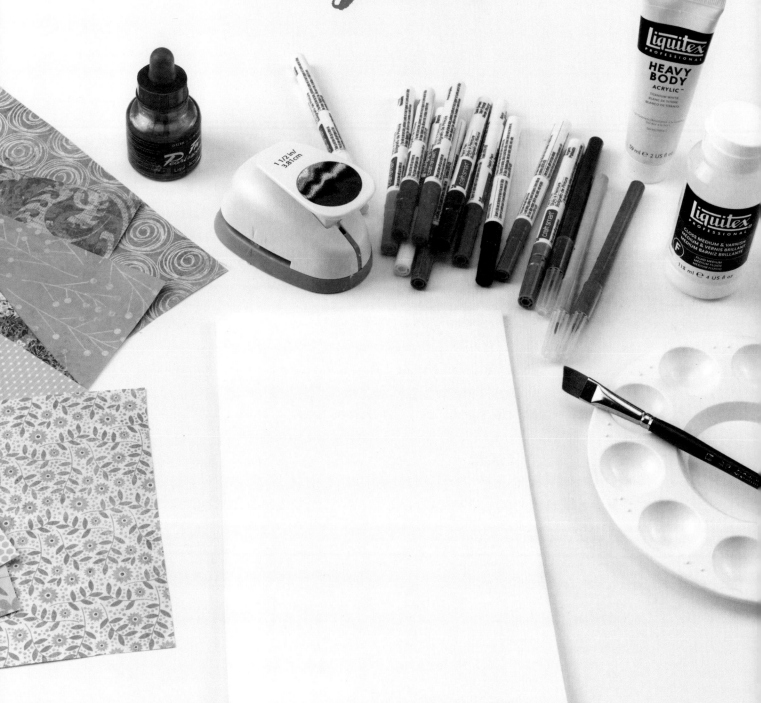

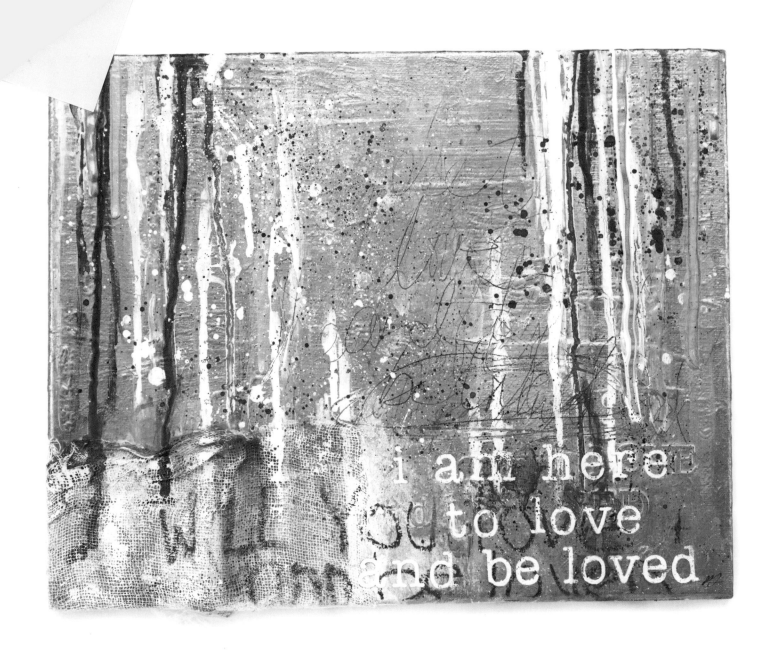

Abstract Painting: To Be Loved

MATERIALS:

11" x 14" stretched canvas
(or size of choice)

Water and water jar

1" thick paintbrush

Small paintbrush

Heavy-bodied (thick) acrylic white paint

Gold acrylic paint

Dark pencil (4B or 6B, or pencil of choice)

White school glue in squeeze bottle

White ink with ink dropper

Spare rag

Palette

Red or magenta ink, with dropper

Small swatch of textured paper, fabric,
or plastic

Red oil pastel (or color close to red)

Stencil/letter stickers

Where Should I Start?

"Life is not a dress rehearsal. Stop practicing what you're going to do and just go do it. In one bold stroke you can transform today."

—MARILYN GREY

New beginnings bring forth a slew of emotions. You may have lost track of the last time you held a paintbrush, but you know that the joy, passion, and authenticity that creativity promises is something you desire. And yet, to every light, there is a shadow. Embarking on your creative journey may also present resistance, self-doubt, and trepidation with a trance-like grip. As you enter into your new creative love affair, expect to feel a full range of emotions. Excitement, fear, bliss, heartbreak, regret, silliness, messiness, and even tears yearn to have a voice. Welcome it all.

Renowned 20th-century short story writer, poet, and novelist Sylvia Plath once scribbled in her journal, "The worst enemy of creativity is self-doubt." How true this is! As your creative doors swing wide open with wild possibility, self-doubt aims to slam those doors shut. But where does self-doubt originate? It stems from criticisms, hurtful comments, and negative beliefs that other people may have inflicted upon you in the past, and the degree to which they take effect varies from person to person.

Special attention must be given to your self-doubt so that your creative fire will not be extinguished. While it is only human for moldy memories of hurtful circumstances to creep in, your truthful expression gives you the power to say "no" to what no longer serves you and "yes" to what feeds your soul. Through the following supportive disciplines, your inner-critic will have no choice but to step aside as you pave the way for your creative journey ahead.

Find your why

Ask yourself often, "Why am I doing this in the first place?" Are you seeking better health? Longing for a renewed passion? Aching for deeper personal identity? Find your *why*. This is your motivation and impetus for all your actions. When your inner-doubter has something to say, return to your why and take actions that serve you.

Passive acceptance

Self-doubt is a bully. Bullies pick fights. Fights require two to tango. When you mentally fight back, you make the inner-doubt muscle stronger. Passive acceptance is an attitude that accepts the discomfort in a non-aggressive way. When you passively accept the discomfort of self-doubt rather than mentally fighting it, the inner-saboteur's messages will atrophy. Easier said than done, I know, but this behavioral psychology tool wins every time. This creative practice alone will change your life.

Invite discomfort to your table

In order to overcome that which you fear, you must run towards it. Our brains are hardwired to avoid fear and discomfort, but taking baby steps toward situations that spark your self-doubt is a sure way to nip it in the bud. When you combine passive acceptance with your short-term willingness to feel slight discomfort, you move toward your creative goals and do not allow distress to halt your progress.

Stop caring about other people's opinions

Your mother, brother, spouse, and boss may all have an opinion. However, what other people think or say about you actually has nothing to do with you, so stop caring so much and start tuning out their static. Other people's perceptions are not facts; they are simply opinions. Put an end to seeking other people's approval and take the creative step of learning to trust yourself.

Do not compare yourself to others

Comparing yourself to others is a poisonous act and a losing battle. If you look hard enough, you will always find someone who is better, prettier, and smarter. You are not here to sing someone else's song; you are here to express your own inner music. The world needs the real you, so focus on your own journey.

Celebrate every single success

Creating an authentically lived life is the most rewarding art project. Every step forward is a cause for personal celebration. Acknowledge yourself

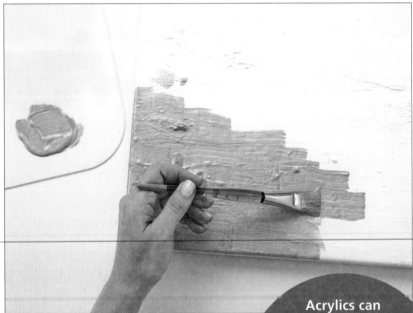

1 Apply a large dollop of heavy-bodied white acrylic paint to your palette. Using the 1″ thick paintbrush, apply the paint in horizontal, intermittent strokes across your canvas. The thick paint should not cover the entire canvas. Instead, create patches of texture on the surface. Allow the thick white paint to dry completely. Clean your paintbrush.

2 Add gold acrylic paint to your palette. Use your clean paintbrush to cover your entire canvas (including the thick textured white paint) with gold acrylic paint. Apply at least two layers of gold paint so that the entire canvas is glowing in gold. Allow these layers to dry.

Acrylics can take five minutes to an hour to dry. Speed this process by holding a hairdryer set on medium 12 inches from the surface. It's ready for repainting when dry to the touch.

for your creative work, become your own biggest fan, and celebrate each small success.

Build your team

Create a loving, non-judgmental cheerleading squad comprised of friends, family, peers, teachers, coaches, and therapists. Nurture meaningful relationships that support the emergence of your greatest self. Let your team root for you and turn to them when challenges arise. Distance yourself from individuals who drain your energy and leave you feeling low.

Just do it

Jump in. Act as if. Fake it 'til you make it. Think less, act more. As you take action, you rewire the parts of your brain that once believed the message of self-doubt. Be courageous, and let those inner-doubters know they are not in control.

Take baby steps

Whether you are learning how to create for the very first time or you are a professional artist, mastery is always achieved in small steps. To expect anything else is to set yourself up for disappointment and frustration. One hundred baby steps transform into massive leaps.

As you contemplate the beginning of your creative odyssey, abstract painting is the perfect starting point to practice the art of staying true to yourself. Through the expressive marks you will make on the project I called *Abstract Painting: To Be Loved*, dare to be bold and infuse every brushstroke you create with the real you.

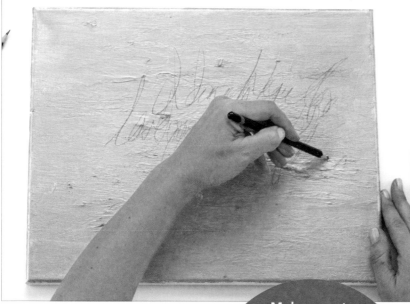

3 With a pencil (preferably a 4B or 6B, which are the darkest pencil color), freely and expressively write something that is meaningful to you on the canvas using large strokes. I wrote, "I am here to love and be loved" multiple times across my canvas. Pick your own wording, always choosing subject matter that is personal to you, the artist.

Make sure to put your paintbrush in water when you are not using it. Acrylic paint dries quickly, and if you do not put your brushes in water, they will quickly dry out and be stiff.

DON'T KNOW WHAT TO WRITE?
Turn your favorite music on, grab a pen and a piece of paper, and spend five minutes journaling. Do not edit or think too hard. Allow whatever is on your mind to flow onto the paper. Use your expressed written feelings in your journal entry as inspiration for your painting.

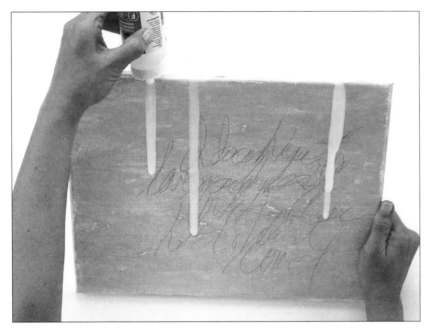

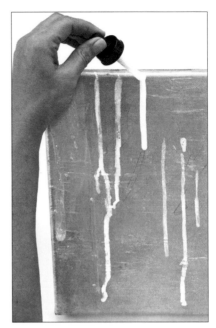

4 Using the pointed nozzle of the white glue bottle, squeeze glue onto three to five areas at the very top of your canvas, allowing the glue to drip down unevenly in long stripes. Lay your canvas flat when you want the drips to stop moving. The glue will be clear when dry, creating an interesting texture to paint over. Allow the glue to dry enough so that it is no longer dripping when you raise your canvas.

5 Fill the white ink dropper with ink. Squeeze the dropper to drip ink on your canvas a drop at a time, creating uneven lines in at least five places. If you want a drip to stop, lay your canvas flat on a table and allow it to dry before adding additional drips.

BE PREPARED
Flicking ink is not an exact science–get ready for the ink to end up in unexpected places!

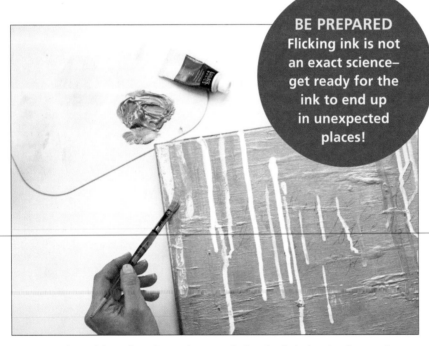

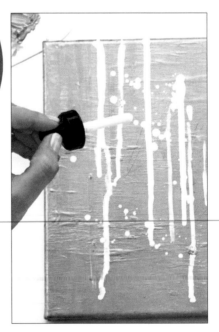

6 Using the gold acrylic paint and your paintbrush of choice, begin to paint over selected areas of your canvas, covering some paint drips while leaving others exposed. This will create a sense of depth, texture, and space rather than a flat appearance. Enjoy experimenting with texture, and apply the gold paint very thickly in some areas and thinly in others. Explore further by using a rag to rub in various areas of gold paint, or use your fingers to massage the paint in to the canvas.

7 Now it's time to make a mess! With the filled dropper of your white ink, splatter the ink onto your canvas by squeezing the top of your dropper while flicking your wrist toward your canvas.

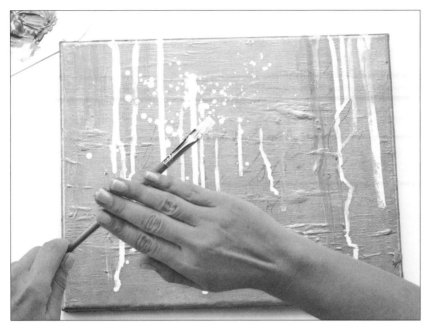

8 Next, using your palette, combine four or five drops of ink with an equal amount of water. Dip your paintbrush in and "scoop" up the watery ink. Hold brush parallel to your canvas with one hand and tap the handle of the brush with your other hand using medium force. This will create clutters of splatters throughout your painting. Let this dry.

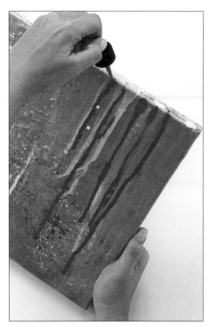

9 Mix red and white ink together on the palette to create pink. Add splatters to the canvas with the pink, using the same method as in Step 8. Fill the red ink dropper with pink ink; place drips on your canvas. Remove unwanted drips with a rag.

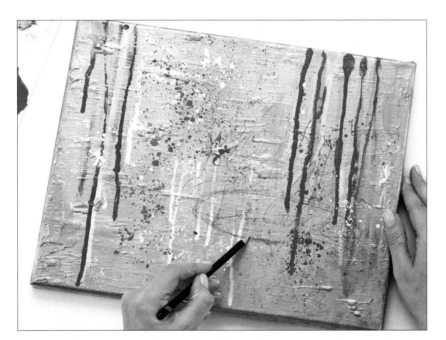

10 Rewrite your expressive words with pencil to create another layer of writing. For further emphasis, loosely circle a part of your written message. Create at least four layers as you switch back and forth between writing in pencil, repainting areas in gold, and splattering and dripping ink and paint. The more layers there are in your painting, the richer it will be. Each layer should dry before you paint over it. Expose previous layers by rubbing away newly added wet gold paint by rubbing your rag in circular motions to either wipe away the wet paint or by leaving just a remaining thin layer of wet paint.

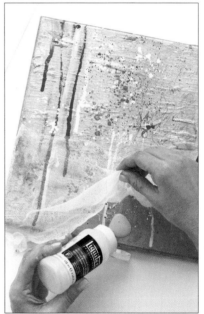

11 Cut a 3" square of interesting textured paper, fabric, or found plastic item. Be creative—art is everywhere! (I added texture with a piece of gauze). Glue your textured piece to the bottom left corner of your canvas.

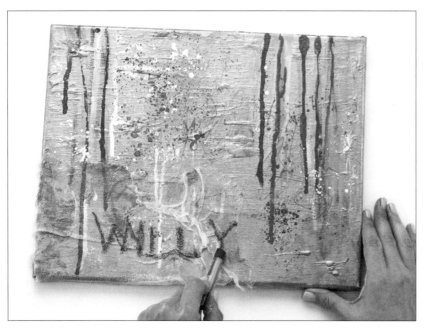

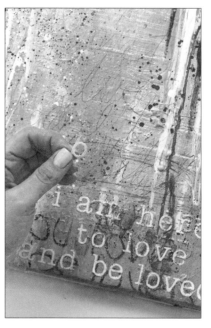

12 With your red-toned oil pastel, write a meaningful expression in bold block letters on the bottom of your canvas. Allow some of the writing to cover the glued textured piece.

13 Using the letter stencil stickers, re-create your expressive feeling or message, sticking the letters to the lower area of your canvas. The stickers will partially cover the red writing from the previous step.

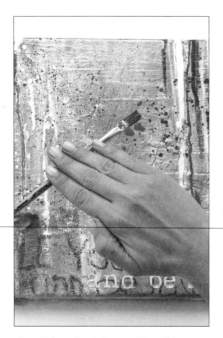

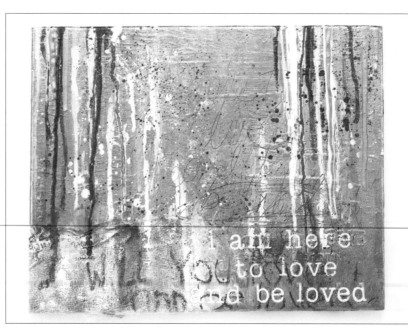

14 As a final step, with a thin paintbrush or your finger, add touches of watered-down gold paint on top of selected letter stickers. Then, add a few splatters of your red, pink, or magenta ink on top of the letters.

Optional additional steps: Add small touches of pink paint and rub them into the stickers with a rag or, using a thin paintbrush, paint over part of one or two stencil sticker letters. When your painting is completely dry, consider adding a thin layer of Acrylic Gloss Medium and Varnish to create a final glossy layer. Congratulations on completing your abstract painting and starting down the road to releasing your creativity!

Want More Texture?

If you love texture, the secret is simple. More paint equals more texture! Look closely at the detail to the right and you'll see glue drips that have been painted over. They add a bold degree of dimension, but the layers of paint and ink add texture in a more subtle way. Use the lighter mediums of thinned paint and ink to add variety and depth in an understated way, and use the thicker mediums such as glue drips, thickly applied paint, or acrylic molding paste to add texture in a more dramatic fashion, depending on the effects you desire in your abstract painting.

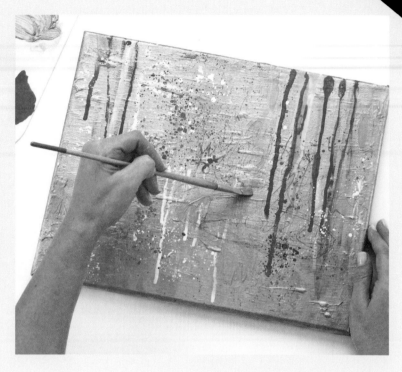

ART & SOUL work

EXERCISE: ENDINGS & BEGINNINGS

What inner self-doubt messages challenge you the most?

List one creative baby step you will take this week.

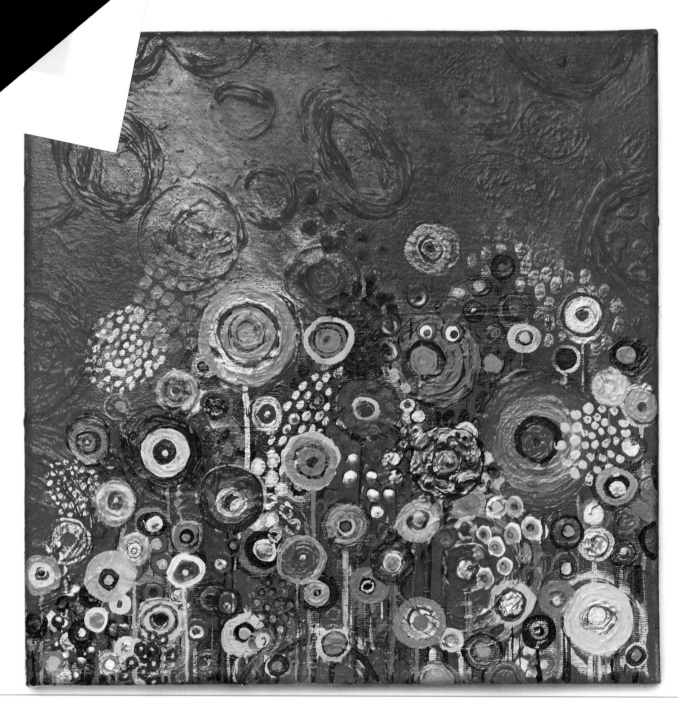

Flowers and Lollipops

MATERIALS:

Square canvas (at least 12" x 12" or larger)

Acrylic paint in colors of your choosing (aim for at least a dozen for variety)

Palette

Palette knife

Assorted paintbrushes

Thin permanent markers

Acrylic molding paste (optional)

Liquitex Acrylic Gloss Medium and Varnish

Water and water jar

Rag

You Are Creative.
(You Might Just Not Know It Yet.)

"There is only one of you in all time, this expression is unique. And if you block it, it will never exist through any other medium and it will be lost." —MARTHA GRAHAM

In the billions of years of life on Earth, there has never been, and there will never be, another you. One of a kind, you were born with a rich, inner treasure called creativity, and you are here to express yourself to the world. While the English word *create* derives from the Latin word *creare*, "to bring into being," creativity itself describes the act of connecting with the deepest expression of your heart. Creativity is a powerful way of communicating with both yourself and the world. Being creative makes you feel alive from the inside out, and authentic expression of your thoughts, dreams, hopes, and emotions allows you to be the best version of yourself.

That creativity is reserved for artists and a select, talented few is a myth that needs correcting. If you are breathing, you are creative, and there are no exceptions to this rule. Sadly, many people find the enjoyment of art to be inaccessible. From snobbish, ice-cold art galleries and incomprehensible museum installations to the judgmental rigidity of some art educators, common misperceptions of art have left creativity seemingly out of reach for so many. In the face of fitting in, academic pressure, societal structure, and the stresses of our demanding world, most people have had their creativity squashed out of them. It is time for an art revolution, and together we must redefine creativity and art.

In the world of creativity and art, there is no right or wrong. While it is often associated with fine art, writing, or music, creativity is not limited to these forms of expression. The canvas is a place that invites the full expression of your soul. By freely practicing your creativity with paint on canvas, you will find your creative power rippling into the corners of your everyday life. Through exploring your creativity, you will discover:

• The freedom to be you while expressing your authenticity and truth

• Meaningful, intimate connection to yourself and to others

• The ability to communicate your thoughts, feelings, and experiences in a safe, encouraging, and non-judgmental space

• The opportunity to learn, grow, and blossom as an individual

• Increased health, wellness, self-empowerment, and self-esteem

• How to create a life of fulfillment

In short, accessing your creativity provides you with the fuel for a meaningful and purposeful life. Honoring the fact that there is only one you, reignite your creativity as you paint a colorfully textured, joyful, and expressive canvas that celebrates the gift that you are to this world. In *Flowers and Lollipops,* you will discover the joy in your unique and newfound creativity.

1 Squeeze a quarter-sized amount of bright pink or magenta (or any color of your choosing) acrylic paint onto your palette. Add a similar amount of water and mix it into the paint with your palette knife. This will be your base color.

2 With a large paintbrush, apply the base color to your entire canvas. There is no right or wrong way to apply your first layer brushstrokes. Enjoy this preliminary layer as an opportunity to play with the paint and explore brushstrokes in any direction that is fun for you. You will definitely paint over this first layer, so do not take it too seriously!

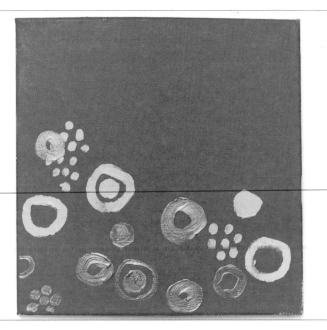

3 Choose two more paint colors and squeeze them onto your palette. With a medium-sized paintbrush, dip your brush into each individual color, and paint various sized circles on the bottom half of your canvas.

THE ANSWER LIES WITHIN YOU

Students often ask me, "What should I do?" or "What colors should I use?" The answer lies within each person. Instead of asking permission or advice from others, inquire within and let your inner artist guide the way. Choose paint colors that make your soul shout, "YES!"

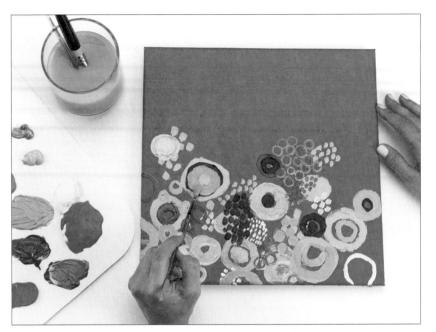

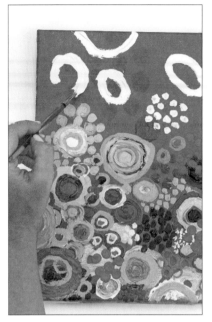

4 Squeeze at least eight more colors onto your palette. You can use color directly from the tube and also mix new colors. A painting is more interesting when you mix colors on your own. With small- and medium-sized paintbrushes, begin to add more circles of various shapes and sizes. When you use a specific color, repeat the same color in at least three different places on your canvas. Allow yourself to overlap circles and patterns to create visual dimension in your painting.

5 Squeeze a large dose of thick white acrylic paint onto your palette, or use acrylic molding paste for more texture. With a medium-sized brush, scoop up the paint and create a circle on the top half of your canvas. Add additional circles, using a lot of paint for each one for texture.

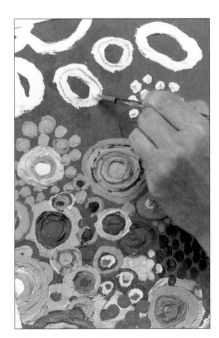

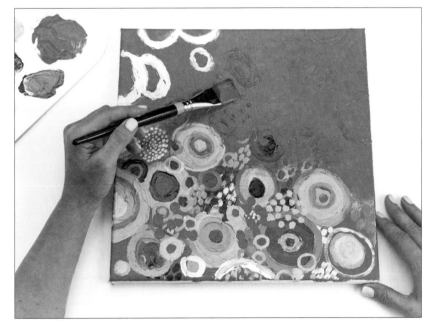

6 Add more white paint if desired. Use the brush's pointed end to gently scrape into the wet paint in circular motions, outlining the white circles to create a 3-D quality. Choose other areas to use this technique.

7 After allowing the white paint to dry completely, mix a new color, or use the first layer paint color (pink), on your palette. Add 4-5 drops of water to the paint to create a thin, transparent consistency. When the top half of your painting is dry, paint a thin layer of color over the white paint. You want all of the texture you have created to show through the newly added thin paint color.

THERE'S NO CHEATING IN ART

Learning about another artist's process can inspire you on your own creative journey. The colors listed here are the ones that I used straight from the tube or custom-mixed in my painting. All colors may be changed according to how much or how little of each color you add to the mix. Through experimentation and practice, you will master the art of color mixing!

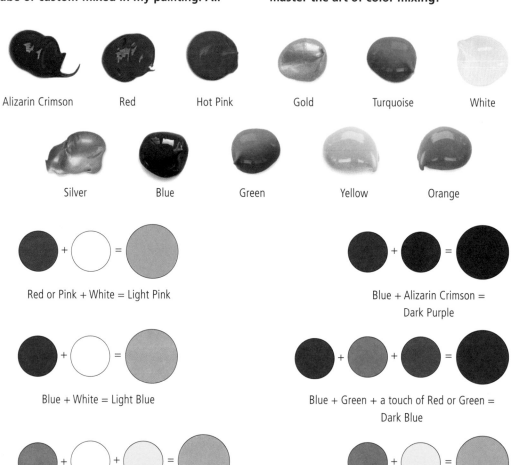

Alizarin Crimson Red Hot Pink Gold Turquoise White

Silver Blue Green Yellow Orange

Red or Pink + White = Light Pink

Blue + Alizarin Crimson =
Dark Purple

Blue + White = Light Blue

Blue + Green + a touch of Red or Green =
Dark Blue

Orange + White + a touch of Yellow =
Tangerine Orange

Green + Yellow = Lime Green

Yellow + a touch of White =
Lemon Yellow

Green + Blue = Dark Green

Green + Blue + a touch of White = Aqua

Blue + Alizarin Crimson +White = Lilac

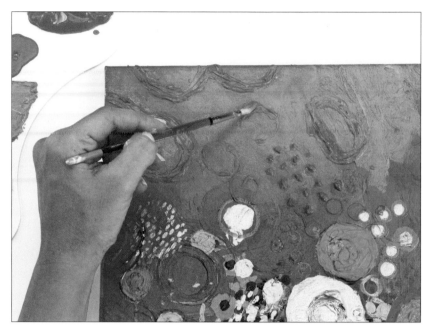

8 Choose an additional three or four colors, either right from the tube or by mixing colors. I mixed two light and two dark shades of pink. Mix a few drops of water into each new paint color to create a thinner consistency. Choose one of these watery paints. With a medium-sized brush, apply a thin layer of this paint in select areas on the top half of your canvas and rub it into your canvas with a rag. Let dry for 3–4 minutes. Repeat this with each new paint color. Let each layer dry before adding another. Previous colors and textures will show through the thin layers of newly added colors. Repeat this technique as many times as you like to create subtle shifts in color.

CREATIVITY AND PATIENCE

If you do not like your painting, no need to fret. Just keep going! Rome was not built in a day, and the greatest artworks of all time were often worked on for many years. By practicing patience, you let go of expectations and embrace the enjoyment of simply exploring the magic of color, texture, and your unique creative process.

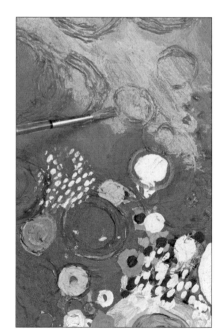

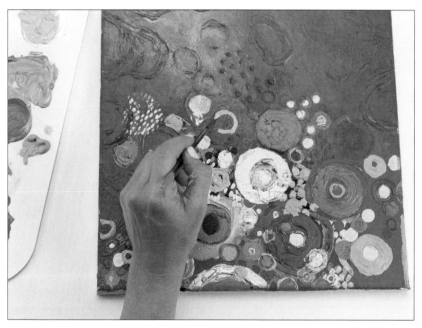

9 With gold acrylic paint or a metallic of your choice, apply a slightly thinned layer to the upper left corner of the canvas with a medium-sized paintbrush. Add thin layers until you achieve a dreamy, ethereal quality.

10 Now that you are a pro with texture, vary the texture on the bottom half of your canvas. Add a variety of colors to your palette—a combination of colors you have already used along with colors that you mix. Continue to add more circle patterns. Redefine, detail, and even paint over patterns that you already painted. Continue to repeat each color in at least three (or more) places on your canvas. Experiment with new patterns, shapes, and colors. Let dry.

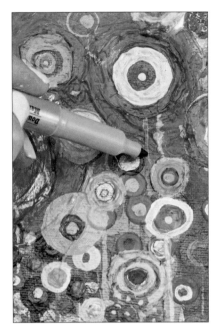

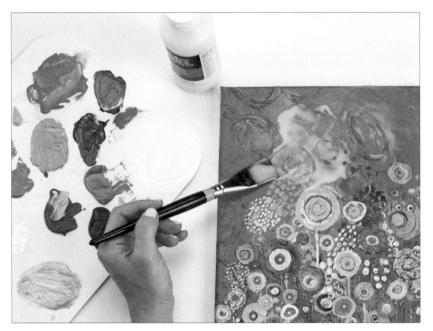

11 With extremely thin brushes and markers, paint and draw straight lines connecting some of the lower circles to the bottom edge of the canvas. Allow some stems to disappear behind other circles for suprising variety. Repeat steps 10 and 11 until you are satisfied.

12 Acrylic paint appears glossy when it is wet and tends to have a matte appearance when dries. If you love the glossy look, grab your Liquitex Acrylic Gloss Medium and Varnish. Allow your canvas to dry overnight. The next day, do a touch test by running your fingers lightly across the entire canvas to make sure your painting is completely dry. Now you can apply a thin layer of gloss, spreading it with a medium-sized paintbrush across your entire canvas with smooth, soft strokes. Do not go over the gloss in a back and forth motion more than a few times or you will get a cloudy result. The gloss might have a white tint to it when it is wet, but do not worry. It will dry completely clear.

PAINT IS VERY FORGIVING

I hear my students whisper, "I want to keep working on my painting, but I am afraid to mess it up." My response? Paint is very forgiving. If you paint something that you do not like, just let it dry and paint over it. It really is that simple. You never have to keep any part of your artwork that you don't like.

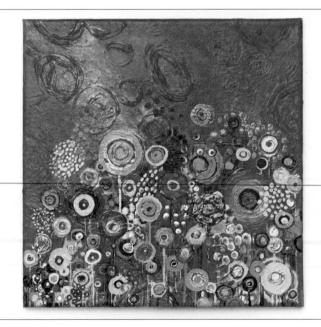

13 Congratulate yourself on being creatively courageous, living in the shades of gray, and surrendering to your greatest inner-teacher—yourself!

I LIKED IT BETTER BEFORE! NOW IT'S UGLY!

Remember: Art is a process. One of the many fulfilling qualities of creativity is that it is *not* product- oriented. Rather, artistic self-expression is process- oriented. *The joy is in the process.* The joy is in the messy, the gorgeous, the ugly, the mistakes, the success, and the feeling of how great it is to express yourself! If you make the creative choice to practice a less judgmental attitude, you immediately welcome more inner peace and joy into your painting as well as into your life canvas.

If you are disappointed or discouraged and find yourself muttering, "I hate my painting! I liked it better before. I shouldn't have changed it. Now it's ugly," it is time for you to take a deep breath and repeat after me: "I am not going to waste my energy on negative comments. I just started this painting. This is not the time to judge. When this white paint dries, I am going to paint over it with gorgeous colors any way I want. I will surrender to the process of my divine creativity. I will now return to having fun!" Take another breath and repeat this again. By practicing non-judgment on and off your canvas, you create more space for beauty, inspiration, growth, and enjoyment.

ART & SOUL *work*

EXERCISE: POSITIVE AFFIRMATIONS

Create a positive affirmation for yourself and repeat it multiple times daily. Similar to a mantra, an affirmation is a short statement that will inspire, uplift, and encourage you. Since the mind does not know the difference between reality and fantasy, affirmations allow you to reprogram any negative beliefs about yourself and transform them into positive, empowering statements. Through practice, you can train your mind to believe your affirmation, and by doing so, you will create new, nurturing life experiences that are fulfilling expressions of the unique person that you were born to be.

Every morning, spend two minutes looking into your own eyes in the mirror and repeat your affirmation to yourself. Feel the truth of your affirmation and know that you are the true creator of your life. Write down your affirmation and tape it to your bathroom mirror as an additional reminder.

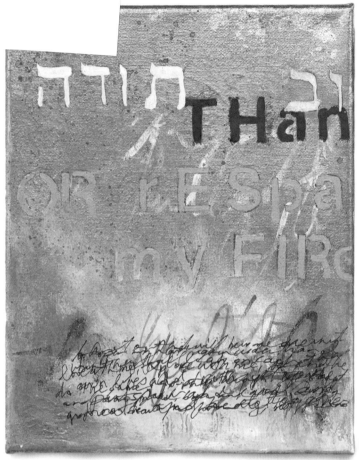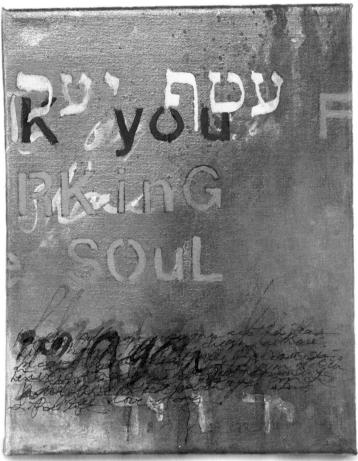

Re-sparking My Soul

MATERIALS:

Two small canvases (same size)	Letter stencils
Artist's palette	Sharp dark pencil (I prefer 3B or 4B, but any pencil will work)
Assorted paintbrushes ranging from very thin to 1" in thickness	Gold leaf (optional)
Water and water jar	Light pink acrylic paint
Gold acrylic paint	Magenta/hot pink acrylic paint
White ink with ink dropper	Dark purple permanent thin marker
White acrylic paint	

Rekindling Your Inner Passion

"Don't ask what the world needs. Ask what makes you come alive, and go do it. Because what the world needs is people who have come alive."

—HOWARD THURMAN

Do you feel that your passion has drained out of you? The ways of the modern world travel at a head-spinning speed. Unrealistic demands, unrelenting competition, and cutthroat societal pressures hound us on a daily basis. Many people have transformed into sleepwalkers who are merely surviving the daily grind. Have you become one of these robots?

On a crisp autumn morning, first-time-student Jill arrived at a mixed-media class at my art studio. As soon as she entered, I sensed the heaviness of her unhappiness. When I asked Jill what brought her to the class, her eyes teared up and her voice trembled. She was a beautiful and successful 43-year-old woman, a wife, and mother to three children. Jill had graduated from art school, then immediately jumped into a promising career as a graphic designer. Soon after, she married the man of her dreams and had her first child, followed closely by her second and third. The years seemed to fly by. But along with throwing away many dirty diapers, she also tossed out her own creativity—the very anchor that had provided her with meaning and happiness. Putting everyone else's needs before her own had left her feeling drained, and disconnected from her own self.

Getting back into painting was a source of anxiety for Jill. Her mind was cluttered with thoughts of "What if everyone else is better than I am? What if I've forgotten everything I learned? What if I don't like what I make?" Desperate to have just a few hours of sacred time to herself each week, Jill courageously made a commitment to her own happiness. She began with a weekly two-hour class. Soon, her passion was reignited as she returned to something that had once been a source of personal freedom and self-expression. She felt more awake and alive. She had meaningful conversations with other women who identified with the same life chapter she was navigating. As she jumped back into painting, her creativity led to a renaissance of her self-esteem and self-empowerment.

Because Jill did not have much free time to spare outside of class, we discussed what other quick creative practices she could try to keep her engaged with her artistic rediscovery. Jill chose to carve out ten minutes every evening. Once her kids went to sleep, she nurtured her reborn passion as she experimented with watercolor paints, colored pencils, and a small sketchbook. She enjoyed this so much that she began spending five minutes

during lunch sketching with pencils. In her spare moments she searched online to learn about art activities that would be fun for her entire family, and her husband started to do the same. She used her iPad during her short commute to look at the artwork of artists she admired, revisting old favorites and discovering new ones. Quickly, Jill began to feel like her former self again.

Jill continued to thrive in her weekly art classes as she restored her sense of self. She began painting large-scale, colorful floral canvases. She never thought she could create paintings like

Reserve time each day for creativity.

these, and her creative success sparked a new set of questions. What else could she create in her life? Could she indentify times when she had stopped herself from pursuing a dream because of fear or insecurity? If she could paint something she never thought she could, where else could she take risks and succeed?

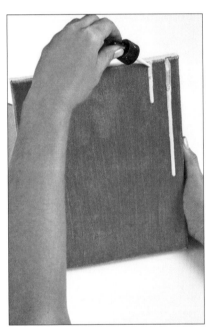

1 On your palette, squeeze out a quarter-sized amount of gold acrylic paint. Add the same amount of water to the paint, and mix with your paintbrush to create a watery consistency. With the 1" thick paintbrush, paint the watered-down gold paint onto both canvases. Allow paint to dry, then add two more coats of gold paint—but this time, do not thin your paint with water.

2 Fill the dropper, then release three drops of white ink onto the top right corner of one of the canvases, allowing them to roll down. As the ink is drying, take a deep breath and close your eyes. Ask yourself, "What do I want to share and express through my artwork? What part of me has something to say?" Jot down all the ideas that come to you. Do not judge yourself and do not edit. There are no right or wrong ideas! You are simply brainstorming. Look over the variety of thoughts you have shared, and circle those that feel the most poignant and meaningful for you.

When you tap into your creative wellspring, you make your happiness a priority and take your worth seriously. Passion and happiness are choices, and choices require action. You must plant, till, water, and care for the seeds of creating a life that you love. Even when self-doubt creeps in like weeds in a garden, do not give up! Be courageous and bold as you embrace this truth: There is only one you on this planet. Do not cheat both yourself and the world out of your bold authenticity and the gifts that only you can offer by forgetting to nurture yourself.

Consistency and commitment are key ingredients to your success in rekindling your passion. Your practice will birth fluency. A simple ten minutes each day is a perfect, and attainable, place to begin. Find ten minutes as if your life depended on it, and consider this time sacred. Cast a wide net and experiment with creative practices that appeal to you. Choose one activity and stick to it every single day as you build your practice slowly and steadily. Experiment with this next art project, *Re-sparking My Soul,* and consider creating it in short daily intervals.

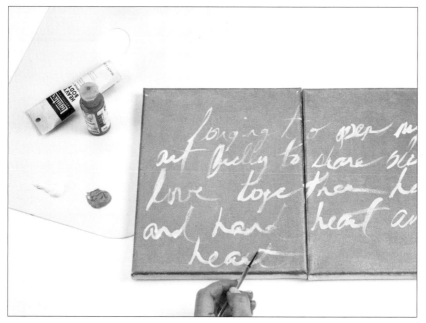

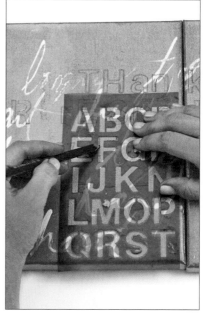

3 Place your canvases side by side to create one larger canvas, putting the one with white ink drips on the right. Using a skinny paintbrush and white acrylic paint with a liquid consistency, "write" one of the thoughts or experiences that you wrote down during your brainstorming session across both canvases. If necessary, mix your paint with water on your palette to get the right consistency. You might write one word over and over, or perhaps you will write sentences. A word from one canvas can continue onto the next canvas. Let your writing be flowing, messy, and expressive. Allow the paint to dry.

4 Returning to your brainstormed ideas, choose a variety of words or a sentence to accentuate in your painting. Using the letter stencils, select a combination of upper- and lowercase letters to trace your words onto the canvases with a dark pencil, allowing the words to flow from one canvas to the next.

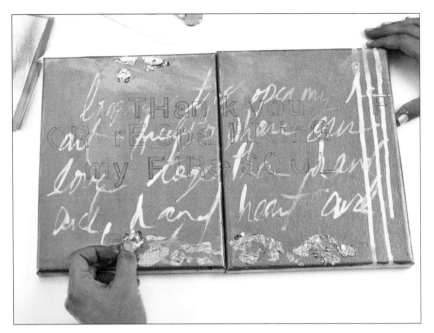

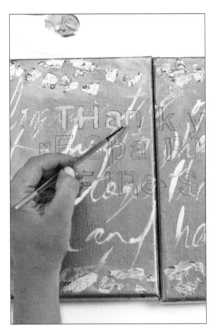

5 With your paintbrush, add more gold paint to the top and bottom areas of your canvases, allowing it to overlap the white script paint in some areas. If using gold leaf, sprinkle one or two sheets directly on the wet paint in the locations of your choosing. The gold leaf should stick right to the wet paint.

6 With a pointed, thin paintbrush and the light pink acrylic paint, paint inside the stenciled letters. Allow the pencil to show in places. If you want the paint to pop, add a second layer of paint. Allow paint to dry fully.

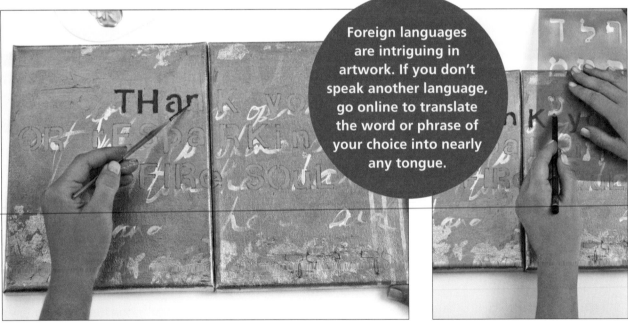

Foreign languages are intriguing in artwork. If you don't speak another language, go online to translate the word or phrase of your choice into nearly any tongue.

7 With magenta acrylic and a thin paintbrush, paint inside the light pink words on the top row (or anywhere else that you would like to accentuate) while allowing the light pink to partially show through here and there.

8 In another language that inspires you (I chose Hebrew), choose an expression from your heart and stencil it in pencil above your top row of painted stenciled letters. Allow the words from the new language to overlap and wrap around the existing stenciled letters.

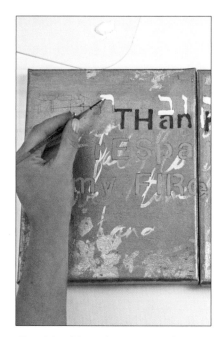

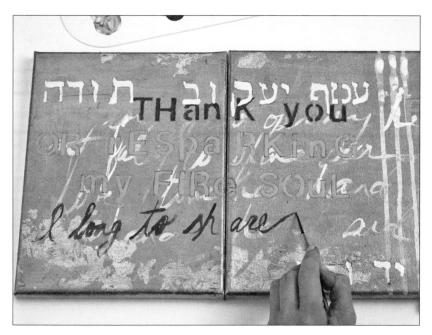

9 With white paint, go over the stenciled foreign language letters with a small paintbrush. Allow paint to dry.

10 Add water to the magenta paint to create a watery consistency. Using a pointy, skinny paintbrush, paint repeated or new words, feelings, and emotions that you want to express in drippy, loose script across the bottom quarter of both canvases. Allow the writing to continue from the left canvas to the right canvas. Let this dry.

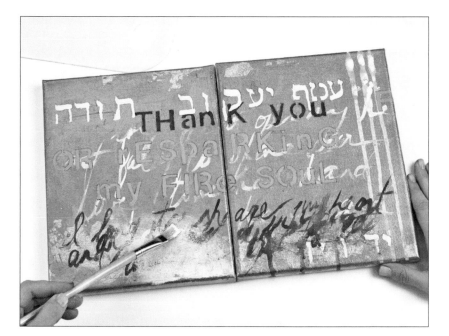

11 Using the dry-brush technique (see explanation at right), add thin white paint to the bottom of the left canvas, and repeat at least four layers of it. Continue to dry brush white paint onto the bottom of the right canvas in small areas of your choice. This will create a cloudy and mystical appearance to your artwork. Next, dry brush light pink and magenta acrylic paint onto selected areas of your canvases.

DRY BRUSHING

Load your clean, dry paintbrush with paint. Remove most of the paint by stroking the brush on your palette. Gently apply your lightly coated brush to your canvas in the direction and stroke of your choice, creating small, continuous back and forth movements that are similar to scratching an itch.

ASK YOURSELF IMPORTANT QUESTIONS AS YOU PAINT

What else do I want to express in my artwork? What am I afraid to say, or what am I longing to give voice to through my art?

To add an important element to you art, your writing does not even need to be legible. It is less about others reading your handwriting and more about you having the freedom to be who you are and express that in your artwork—and in your life! Allow the canvas to be a visual journal of your inner world. Write anything that comes to mind. There is no wrong way to do it. If you wish to share that part of yourself, you can make the words legible on the canvas. But if you prefer to keep them secret, you can paint over them and only you will know they are there.

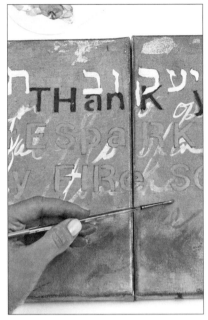

12 Apply and massage gold paint with your brush or fingertip to any area on the canvas where you desire the paint to visually pop and draw attention. Or, add more paint with a thin paintbrush in specific areas. Repeat steps 10–12. Let dry completely.

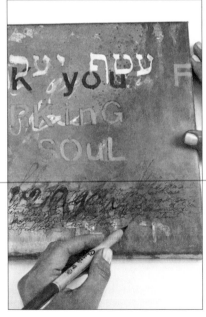

13 With a permanent, thin, dark purple marker, write words and sentences in a free-form, expressive script on the bottom third of your canvases. Create as many layers of writing as you like.

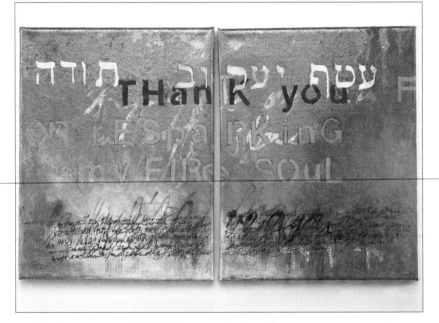

14 When you are satisfied with your painting, allow your canvases to dry completely. Enjoy the good feelings you have generated by reigniting your creative fire.

EXERCISE: 10-MINUTE-A-DAY PLAN

Regardless of busy schedules, everyone can find 10 minutes daily for self-care. Make a "passion list" below of activities that excite, intrigue, or interest you. Choose ideas that are easy to practice at home or in a convenient location, and write down experiences that make you feel alive. Do not overthink it, and do not be afraid to explore out of the box! Ideas might include dancing to music in your living room, singing in front of the mirror, sketching pictures from your travels, or walking in nature. Once you have completed your "passion list," select just one of the activities. Schedule it into your calendar at the same time every single day for a ten-minute period. Give your passion a jump-start and consistently commit to your 10-minute-a-day practice with activities from your "passion list."

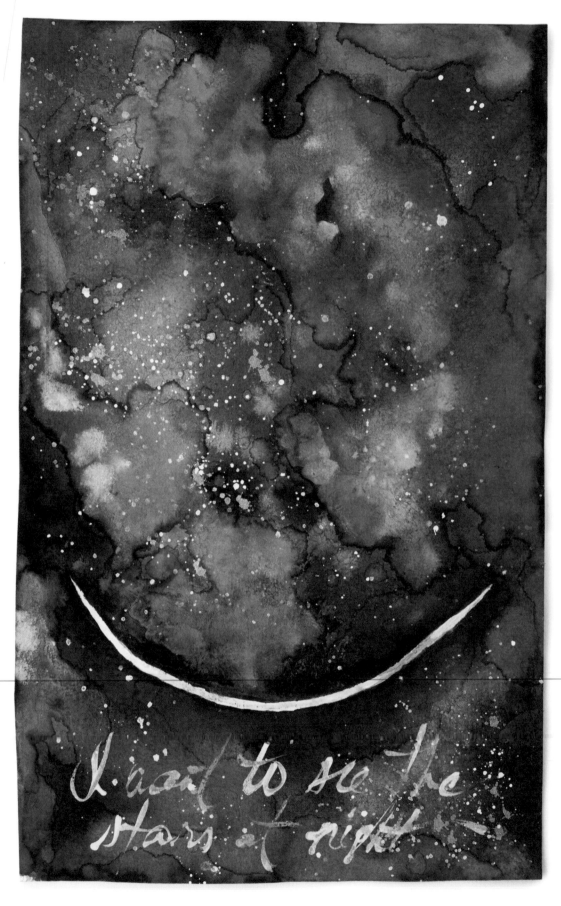

I Want to See the Stars at Night

Learning to See

"You cannot discover new oceans unless you have the courage to lose sight of the shore."
—ANDRÉ GIDE

As you begin to paint and become more creative, you will also learn how to see. Suddenly, the sky you have always looked at has deeper, brighter colors than you had ever noticed previously. The thick woods now have 200 shades of green rather than two. You begin to notice shapes, sparkles, wrinkles, and richness around you, and you start to see the world differently. It is as if you never knew what you were missing until now.

In 2005, I led a painting retreat in Tuscany, Italy. Nora, a vivacious octogenarian, was a participant in the painting workshop. Although she had never picked up a paintbrush in her entire life, Nora was adventurous, and eager to dive into a new creative pool. Among the lush hills and oversized, blue-purple grapes growing on vines, Nora absorbed her surroundings like a sponge. Inspiration overflowed as she dared to draw, paint, and express herself through art. Our 20-participant group was amazed at how quickly she was able to translate her unique personality and newfound knowledge of artistic techniques and self-expression into vibrant, playful paintings and collages.

One evening, weeks after I returned home to New York City, my phone rang at an odd hour. "Rebecca!" an excited voice exclaimed as I answered the phone. "You will never believe what I am looking at right now!" Nora's voice buzzed with pleasure. "I am looking at the sunset at home in

MATERIALS:

Thick/heavy sketchbook or watercolor paper (any size)

Pencil

Optional: round shape to trace

Watercolor paints

Paintbrushes of various sizes

Water and water jar

Fluid white acrylic paint

Silver acrylic paint

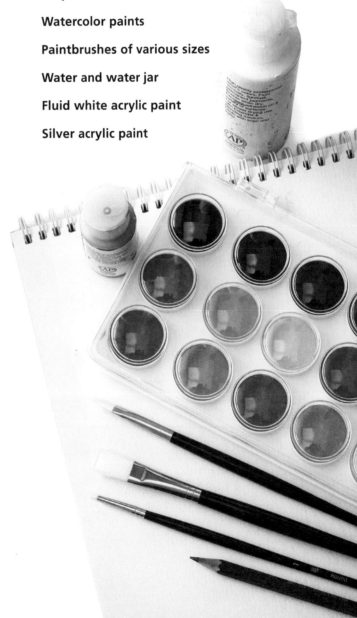

Palm Desert, California, and I am seeing colors that I have never seen in my life: electric pinks, brilliant blues, lively oranges! I am awestruck!"

Nora paused, then said quietly, "I have looked out onto this exact desert sunset night after night for over 30 years, and I have never seen *any* of these colors until now. Rebecca, you gave me an immeasurable gift. You taught me how to see. At 85 years old, my life has been transformed."

Regardless of age or creative experience, you can deepen your appreciation of life and your relationship to the world just like Nora did. When you choose to ignite your courage and experiment with an unfamiliar experience, you begin to appreciate—and see—the profound beauty that is right in front of your eyes. In her eightieth decade,

Give yourself time to truly see something new.

Nora started to see the world through a more fulfilling lens. If she could do it, so can you.

In the following project, which I called *I Want to See the Stars at Night,* we will examine and play with the many colors that can be found in what may first appear to be a basic night sky. As you explore the magical flow of watercolor painting, you will naturally begin to sharpen your own ability to see and recognize beauty. You'll find you *want* to see things in a whole new way.

1 On a white piece of heavy paper or watercolor paper, lightly draw a skinny sliver of a new moon. If you prefer to trace a round object, trace one curved edge of it lightly with a pencil, and then move your round object up ¼" on your paper and draw the same curve again. After the two curves are drawn, lightly sketch lines to allow the points of the moon to attach on both ends. Using a paintbrush, wet your entire paper with a thin layer of water.

2 Choose a shade of blue watercolor paint that you love and mix it with water in your watercolor tray. NOTE: See page 47 for tips on mixing watercolors. Using a medium-sized paintbrush, paint your entire paper blue, avoiding the new moon sliver you've already created. As it is drying, add another shade of watered-down blue or purple paint, mixing it right into the color you've already added.

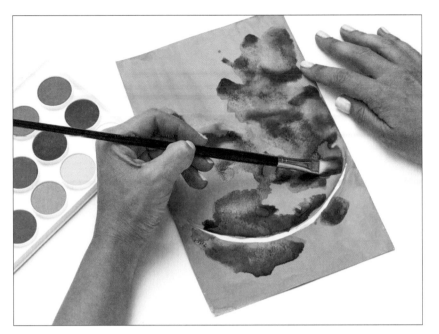

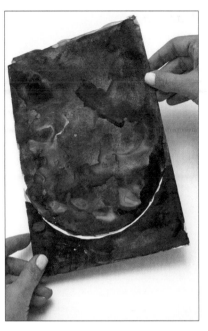

3 Create splotches of watered-down watercolor paint throughout your entire painting, and let the various splotches and "pools" of colors mix and connect with one another. Use blues, purples, greens, and tiny touches of black.

4 While your paper is still very wet with paint, lift it up and tilt it in various directions, allowing the paint to move all around the paper. You will see the paint dripping and expanding throughout, and the colors mixing together at times. Let all paint dry.

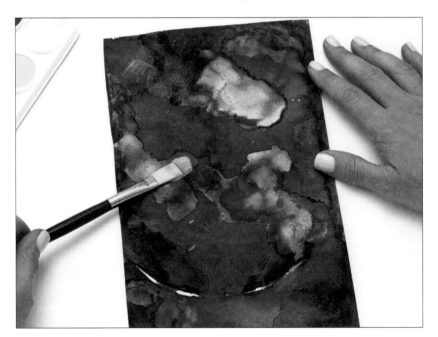

5 Do not worry if paint gets on your new moon. You will paint over it later to redefine the shape if necessary. Let this layer dry.

6 Repeat steps 3 and 4, this time including a watered-down light gray watercolor and adding it four times as a splotch of color in various areas of your painting. Let it dry.

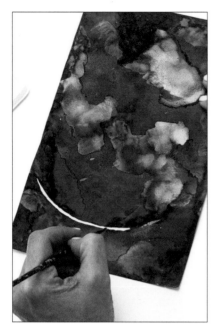

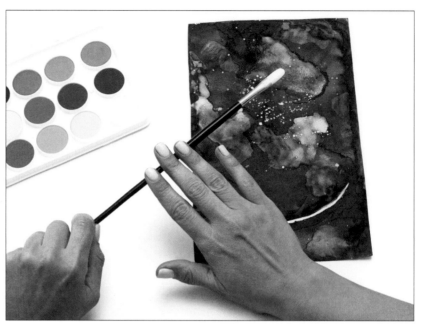

7 With a skinny paintbrush, repaint your moon using white acrylic paint. (If the paint is thick, add water for a fluid consistency.) If you paint outside of the lines, don't worry! You can touch it up with watercolor paint. If necessary, add another layer of white acrylic paint once the first layer is dry.

8 Clean the paintbrush, then switch to white watercolor paint. Swish your brush thoroughly into the white watercolor paint and dip it quickly into a drop of water on your palette. To splatter a sky filled with stars, hold your brush parallel to your paper. With your other hand, tap the paintbrush, knocking drops of white paint onto the canvas. Notice how the splattered stars range in size. Repeat this step as many times as you would like until you are happy with your star-filled sky. You may do the same splattering with silver acrylic paint if you prefer sparkle in your sky.

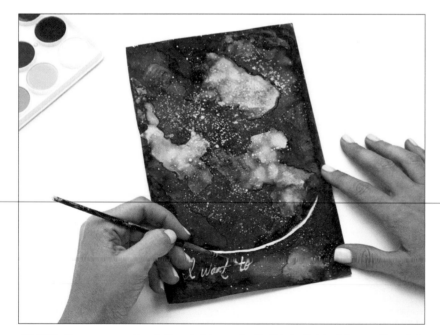

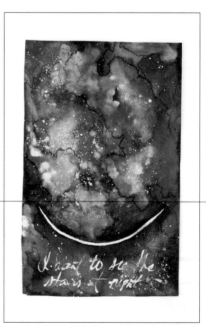

9 With the same small paintbrush (cleaned), dip it into fluid white acrylic paint. Freely write something expressive and meaningful to you on the bottom portion of your artwork. As a city dweller who longs to look out the window and gaze at the stars, I wrote, "I want to see the stars as night." Add something personal, but don't overthink it.

10 Add any touch-ups necessary. If you want to redefine your sliver of moon, either add more paint to your moon or add darker watercolor paint outside of your moon to redefine the edges.

How to Mix Watercolor Paints

Watercolor paints are easy to paint with and even easier to mix! Lightweight, portable, and quick to set up and clean up, watercolors are the perfect creative tool when you desire a lightweight, transparent, and meditative paint to use for all types of artwork, including landscape painting, abstraction, realism, or even quick, five-minute sketches.

Whether you are using watercolor tubes (moist color) or pans (dry color), adding water to your paint is an integral step. The amount of water you mix with each color determines the color, value, and brightness. When you want your color to be vibrant, add less water, and when you want your paint to be transparent, light and soft, add more water. Using a palette with wells is a standard and useful way to mix watercolors, but there are other, less common techniques that can be used for special effects.

Add varying amounts of water to each of the palette wells, wet your paintbrush, and stroke your brush into the desired pigment. Dip your paintbrush, now with paint on its bristles, into the water. Your water will immediately transform into the color that was on your paintbrush. Your watercolor paint is ready.

Continue to add water into each of your palette's wells. Experiment by adding more than one stroke of color into the palette's puddles of water. Notice how the appearance of each color differs according to how much pigment you add to the water.

WET ON WET TECHNIQUE
Immerse your clean brush into clean water; wet your paper thoroughly. Dab paint onto the wet paper in at least four places. This technique allows paint colors to mix naturally with one another while flowing freely and organically in your artwork.

WET ON WET COLOR MIXING
Mix paint colors right on your wet paper. By creating brushstrokes of yellow and blue, the paint automatically turns green where the two colors meet. Experiment with various color combinations.

ART & SOUL work

EXERCISE: A BEAUTY WAKE-UP CALL

From a plant in your home or a tree outside, clip off one leaf. Make an inner promise to take this leaf with you everywhere you go for a 24-hour period. Look closely at its intricate veins, its overall shape, and unique flaws, and appreciate its variety of colors, shades, and textures. Place it in your line of vision at home or at work, and keep it on the table where you eat your meals. Spend a full two minutes staring at your leaf multiple times throughout your day. Be aware of how the relationship between you and your leaf shifts as your day unfolds, and notice if you have developed a deepened appreciation for its beauty. At the end of this exercise, become aware of how your visual appreciation of your leaf deepened over the course of the day.

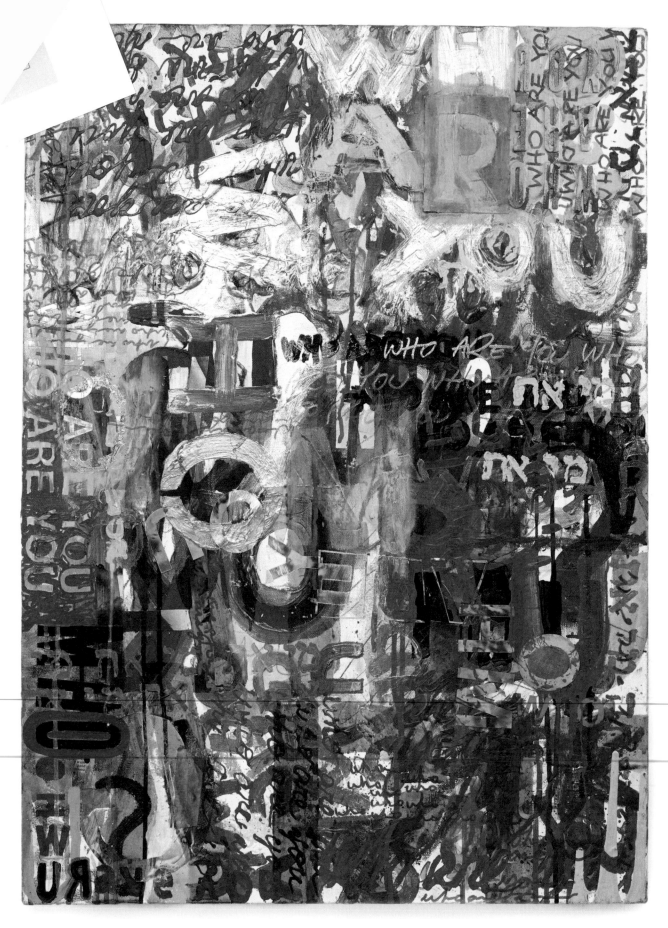

Who Are You?

Being Seen, Heard, and Understood

"Being safe is about being seen and heard and allowed to be who you are and to speak your truth." —DR. RACHEL NAOMI REMEN

Every person needs, and even aches, for genuine connection with others. When your essential thoughts, feelings, and desires are acknowledged, you feel visible to the outside world. You matter. When you are seen, heard, and truly known by another, you experience life's greatest gift: love.

From the moment you enter this world as a baby, you rely on connection. Your life literally depends on it. In fact, science shows that infants who are not consistently held and embraced stop growing. Regardless of proper nutritional intake, if connection in the form of touch is withheld from a baby long enough, he or she will fail to thrive.

How easy it is to spot a child's need for consistent recognition. "Mommy, daddy, watch me swim! Listen to the new song I made up! Do you like it? Look at me!" Children long for loving acknowledgment from their primary caretakers. They need to know that the ones they love the most see and understand them. In some ways, we never outgrow this need. Regardless of our age, we all call on others to provide the sacred testimonial we crave the most—the promise of emotional safety within the embrace of love and understanding. In essence, when you rely on another for this acknowledgment, you metaphorically ask, "Do you see, hear, and understand me? Please watch me, because I need you to affirm my existence. Your love gives me permission to be the real me."

MATERIALS:

Large canvas: 30" x 24" or a size you are comfortable with

Acrylic paint (assorted colors)

Palette

Palette knife (for mixing paint colors)

Assorted paintbrushes

Permanent (Sharpie or Bic) markers in assorted colors and sizes

Letter stencils sized small, medium, and large

Pencil

Tube of squeezable puffy paint with a pointy, small nozzle (any color)

Letter stickers in various sizes, colors, and textures

Water and water jar

Liquitex Acrylic Gloss Medium and Varnish

Optional: Stencils in the alphabet of a foreign language appeals to you

However, relying on others to affirm the entirety of who you are is a tall order that is impossible to fill. Surely, you've endured experiences in your life when you were *not* acknowledged or seen. These moments of personal invisibility can equate to a confidence beating. Whether you are five or fifty-five, it is deeply painful to feel ignored or misunderstood. Even in the most loving of circumstances, the roads of a relationship are paved with the complex cracks of mistakes and imperfections. This pavement is not solid enough ground to hold your full existence. Look elsewhere for affirmation. You must find it within yourself.

For example, when you show your painting to a friend and he is nonresponsive, does it mean that your artwork is a failure? Of course not. It just further clarifies that each human being has a right to their own experience and personal perceptions. Just because Jeffrey does not like your painting does not mean that your artwork, your life, and your expression, is not worthy of being celebrated. Never hand so much power over to someone else. Rather, seek the validation you crave from within yourself.

Your artwork is a mirror reflecting your psyche and spirit so you can see, hear, and understand yourself. The canvas never lies; it is a secret and yet accessible passageway into your soul. Art of all kinds is a safe, welcoming space for you to express every single part of who you are. The ever-changing landscape of your experience is given a showcase through the application of transpar-

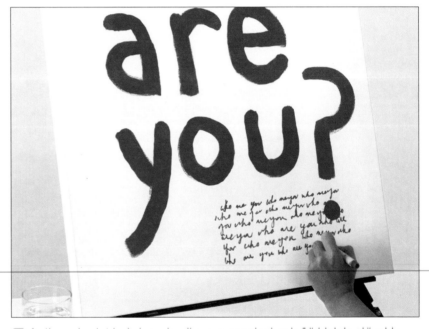

1 Place your canvas in "portrait" position so that it is taller than it is wide. Mark the top of the canvas with a dot of red paint. (You will flip your canvas often in all directions; this dot indicates the top.) Coat a medium-large (about 1″ wide) paintbrush with red paint. In large, freehand letters, write "Who are you?" mixing upper- and lowercase letters. Let it dry.

2 As the red paint is drying, visualize a rectangle that is 2″ high by 4″ wide underneath the red "you." With a bronze-colored thin marker, write "who are you" continuously, over and over, in expressive and free-flowing script writing within your invisible rectangle.

ent ink, subtle washes, reflective pencil, and bold thick, dripping paint.

As an artist, you have the freedom to transform your future and heal your past while nurturing self-acceptance and self-understanding. You can scrape away layers of disappointment and hurt that no longer serve you and add fresh brushstrokes of awareness and self-love. Through artistic truth telling, the hidden corners of your private world can be made into visible, powerful affirmations of your own existence.

As you become more confident in your identity, you will feel more comfortable sharing yourself with others. Giving yourself this freedom is such a relief. You no longer have to hide, shrink, or deny yourself the love that you deserve. With nothing to prove to others, you can make a bold statement that says, "I will no longer hold back. This is ME!" Courageously express all of the rich layers of who you truly are through the following painting on canvas, and give yourself the gift of emotional safety by being seen, heard and understood through your self-expression.

I named this work *Who Are You?*, using this phrase as the inspiraton for my painting. Is there a special word or phrase that resonates with you? Is there a feeling or experience that you are eager to give voice to? Sit quietly, listen to your inner guide, and trust the voice of the artist within. The result will be an outward manifestation of the you that you know and understand. Let who you are become a coherent expression of your truest self.

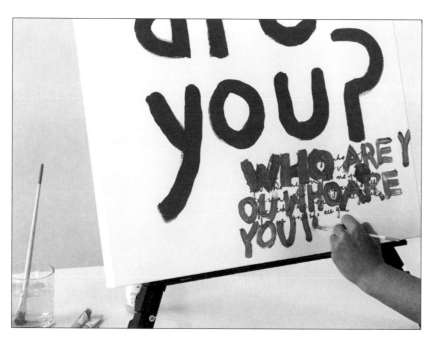

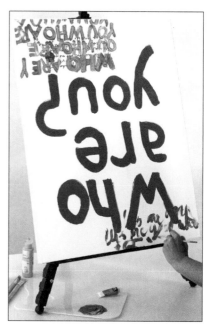

3 Dip a medium-sized paintbrush into your bronze paint, and in the lower right corner of your canvas, write "WHO ARE YOU" in all capital letters. Repeat this at least four times, one line on top of the other. Allow one of your lines to trail off the bottom of the canvas so that you only see the top half of the letters.

4 Flip your canvas upside down, and once again, with bronze paint, write "Who are you." This time, make the size and font slightly different. Be creative and experiment with letter styles you never ever knew you had.

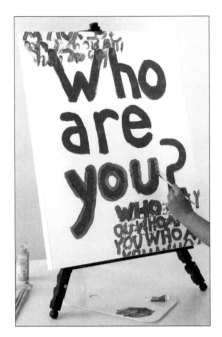

5 Using a medium-sized paintbrush and bronze paint, outline the large, red letters of "you" from step 1. The red will be inside of the bronze outline.

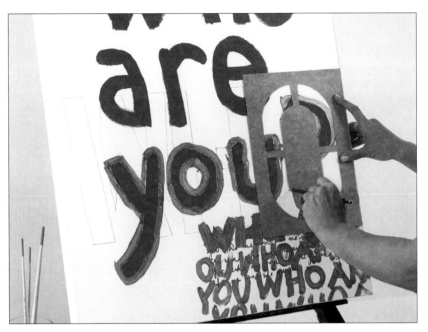

6 Next, with the largest possible stencils (should be at least one-third of the height of your entire canvas), use a pencil to stencil the word "WHO" in the middle of your canvas. Below it, stencil the word "ARE" so that the bottom third of the word falls off the canvas, thus stenciling in only the top two-thirds of those letters.

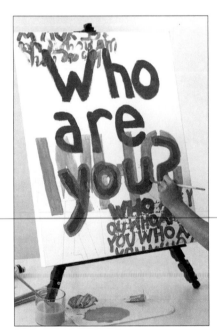

7 With a medium-sized brush, add water to a dab of aqua acrylic paint on your palette. With this paint, paint inside the large stenciled "WHO" and "ARE" from step 6. This will overlap previous letters you have already painted. Let it dry.

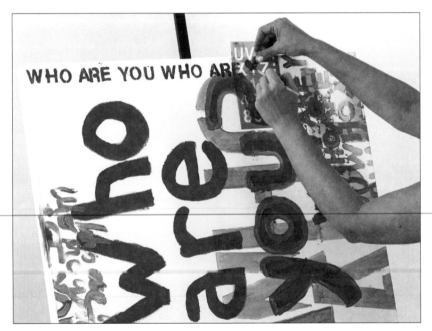

8 As the paint is drying, turn your canvas once clockwise. Place five different acrylic colors on your palette, such as the gold, dark blue, red, orange and lime green I selected. Be sure to experiment with mixing custom colors instead of sticking to colors straight out of the tube. With a small lettering stencil (either English or a foreign language), stencil "WHO ARE YOU" in a blank area. On at least four additional spots on your canvas, stencil "WHO ARE YOU" using a new paint color and turning your canvas each time. Consider painting on top of paint that is already dry so that you build more layers on your canvas. Let it dry.

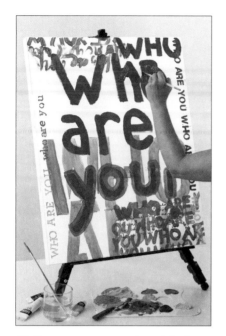

9 Turn your canvas to its original upright position. With bright blue paint, use a medium to large paintbrush and write "WHO ARE YOU" in freehand in the upper right corner. Allow the paint to be very thick!

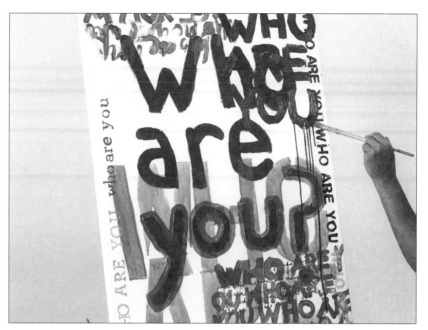

10 Mix a teaspoon of water to the blue paint on your palette. The paint should have a watery consistency similar to ink. With your paintbrush, scoop up the watery blue paint, and press your brush down onto the "YOU" from step 9. Your canvas should still be in the upright position. Allow the blue paint to drip down your canvas. Repeat this step across the bottom of the word "YOU" at least eight times. To stop the drips, lay your canvas flat. If you want to wipe away a drip, simply wipe the wet paint off with a rag. Let this dry.

STENCIL OR PENCIL?

When stenciling, you can place your stencil on your canvas, trace the shape, then paint inside the lines. Or, you can paint directly on the stencil. For letters, you will move or change the stencil often, so you may want to wait a minute or two for each letter to dry before stenciling the next.

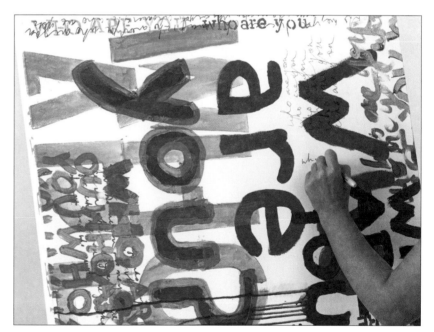

11 Turn your canvas once clockwise. With a marker of your choice, in small expressive script, write "who are you" across the bottom edge of your canvas. Continue to write "who are you" over and over again in the same font and same marker color in at least five new places on your canvas. In some areas, stack the phrase, one line on top of the other. This will create a feeling of pattern in your artwork. Turn your canvas clockwise again. (Your canvas should now be upside down.) Repeat this step with a new marker color. Turn the canvas clockwise again and repeat this step once more.

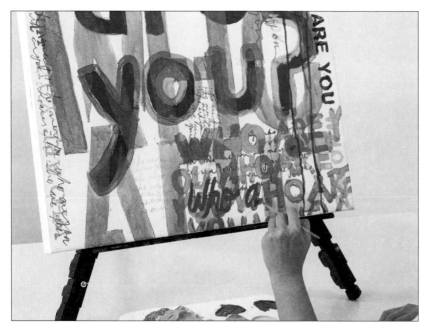

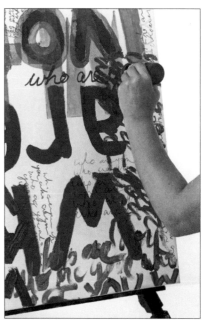

12 Turn your canvas clockwise so that it is in the original, upright position. Add magenta acrylic paint to your palette. With a thin paintbrush, use expressive script to write "who are you" in a medium size in the lower right corner and the upper left corner. (In a foreign language or in English.) Turn your canvas clockwise again and add the phrase, in the language of your choice, to the upper middle of the canvas, stacking it three to four times. Turn your canvas clockwise one more time.

13 Squeeze the red puffy paint bottle so the paint flows slowly as you write "who are you" at least five times on the canvas's right middle side. Turn clockwise again and stack the phrase at least six times at the bottom right. Turn the canvas upright.

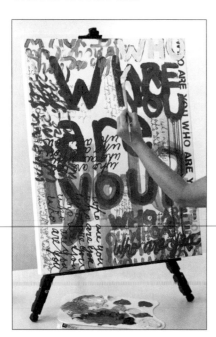

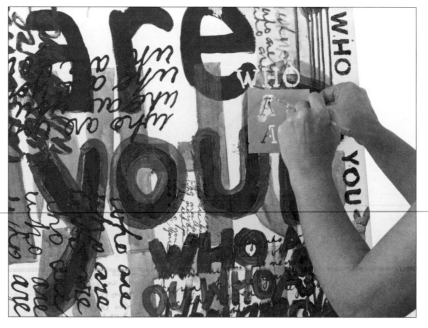

14 Add off-white acrylic paint to your palette. In the upper right corner, paint thickly over all but one letter of the large blue "WHO ARE YOU" with a 1" brush with the white paint. Use the pointed end of your brush to scrape into the wet white paint, exposing the blue paint.

15 About 3" below the area you painted in step 12, and with the same off-white paint, use your small stencils to write (either in a foreign language or English) "WHO ARE YOU" at least twice. Allow one stenciled phrase to be closer to the edge of the canvas than the other so that the two phrases do not line up perfectly.

54

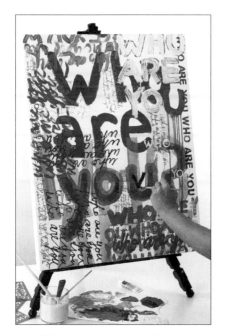

16 Add dark purple acrylic paint to your palette. Paint a medium-sized "YOU" one-third of the way down the canvas to the right. Paint "who are you" in a mix of freehand and stenciled letters halfway down and slightly to the right.

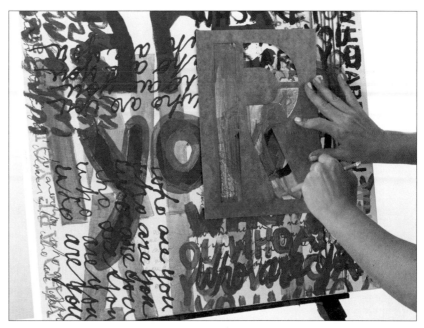

17 Place lavender acrylic paint on your palette and with your palette knife, mix it with about one teaspoon of water. With large stencils, on the right side of the lower half of your canvas, stencil "R" and "U" in lavender with your canvas upright so the paint drips down. The previous layers will show through. Choose another area at the top of your canvas to write "who are you" in lavender, allowing the paint to drip. Lay your canvas flat when you are happy with the placement of the drips. Use your rag to wipe away any excess paint.

AUTHOR'S NOTE

Although I share which colors I used for my painting, and how I applied layers of words and fonts in this project, these are simply examples for the purposes of explaining the process. You need not follow my example. Trust your own intuition and choose colors, textures, and patterns that appeal to you and express something about yourself.

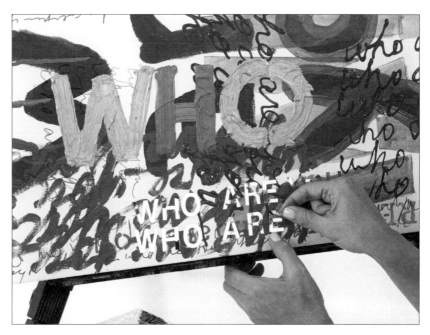

18 Turn your canvas once clockwise. Using your stencils and a combination of silver and lavender paint, stencil in "WHO" on the lower left half of the canvas. At this point, you will have many layers showing through the new paint. Let this dry. Below the silver and lavender letters, use silver alphabet stickers to spell "WHO ARE YOU" at least twice, stacking the phrases on top of each other. Once you have done this, use a metallic blue marker and scribble around the stickers you just added in a loose and expressive way.

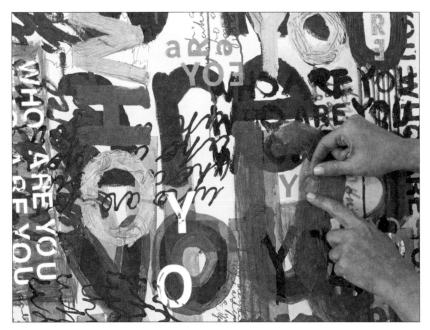

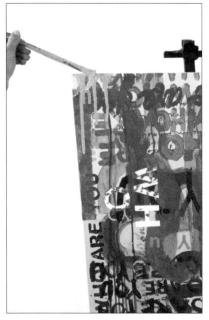

19 Use silver metallic stickers (either same size as used in step 18 or larger), to spell "WHO" near the bottom left corner. Consider breaking up the letters so they are not all on one line. With the same stickers, add "ARE" and "YOU" in random directions. Continue to place any stickers you find interesting on your canvas. Place some upside down, sideways, and overlapping previous layers of paint to make your painting more interesting. Once you are satisfied, consider adding a bit of Mod Podge or glue to permanently adhere the stickers.

20 Add yellow acrylic paint to your palette. Turn your canvas upside down and apply three thick drips of yellow paint so they roll down your canvas. Allow the drips to fall no more than 3" to 4" and then lay your canvas flat to dry.

A FEW TOUCHES

Add "who R U" in stenciled red paint in the lower left-hand corner with letters going in all directions. Try new freehand lettering styles with a variety of markers and paintbrush strokes, or outline some of your words with markers. Add "WHO ARE YOU" with stickers once or twice more.

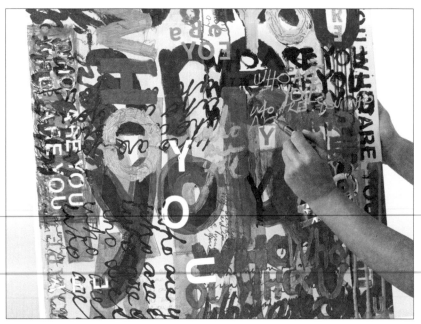

21 Add a generous amount of water to the yellow paint on your palette so it has a thin, ink-like texture. Choose at least three areas where a pop of color is needed, then apply splotches of watery yellow paint with a paintbrush. Once you add the watery yellow paint, rub it into your canvas with your rag so that it has a smooth and glowing effect. Turn your painting right side up. Continue to create additional layers of lettering with acrylic paint, markers, stickers, expressive color and textures that are exciting to you (suggestions at left).

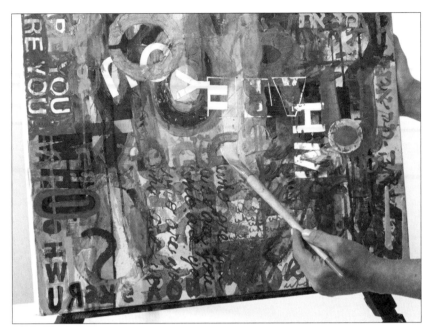

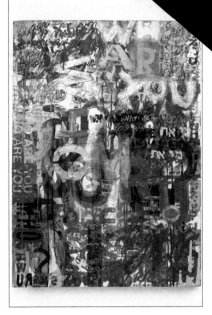

22 When you are finished and your painting is completely dry, pour at least two tablespoons of Liquitex Acrylic Gloss Medium and Varnish onto your palette. With a clean, dry and thick paintbrush, paint an even layer of the gloss onto your entire canvas. The gloss will give your painting a final, shiny topcoat. Do not excessively brush the gloss back and forth on your canvas. Once it is applied in one thin layer, leave it to dry, or else it may create a cloudy film on your artwork.

23 Celebrate yourself for trusting your intuition and expressing the magnificent artist that you are!

ART & SOUL *work*

EXERCISE: OPEN LISTENING

This powerful exercise is done with a partner. Sitting face to face, ask your friend a question about themselves or allow them to speak about anything that is on their mind. Listen to their response without comment or interruption and without using any body language or facial expressions. There is no agenda other than to hear and receive the person across from you. Witness your partner. Listen with all you have.

After four minutes, switch roles with your partner. Answer a question or share your own thoughts. Allow yourself to be vulnerable and honest. Experience what it feels like to be completely listened to, received, and acknowledged.

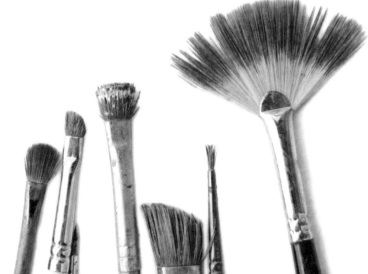

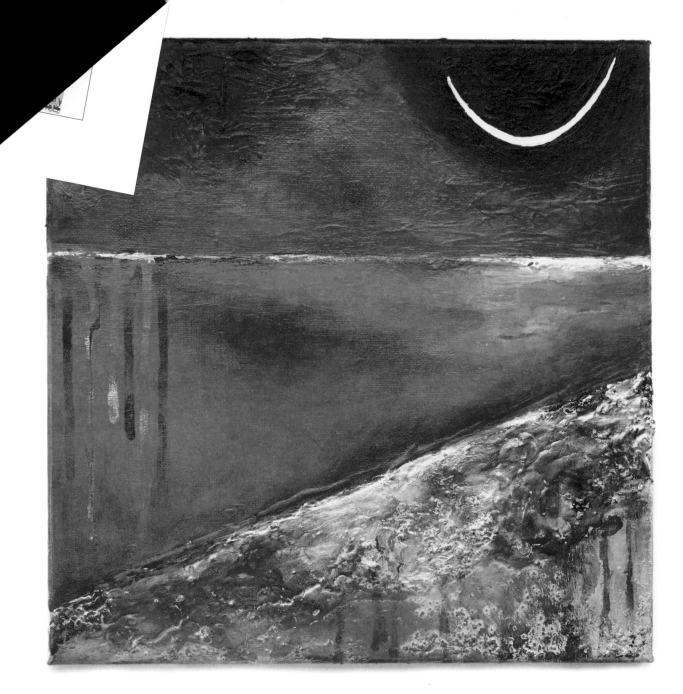

Peaceful Night Sea of Tulum

MATERIALS:

Square canvas, size of your choice

Acrylic paint: pthalo blue, ultramarine blue, turquoise, white, silver, light pink, deep purple

Assorted paintbrushes

Palette

Pencil and paper

Retarder gel (optional)

Molding paste

Liquitex Acrylic Gloss Medium and Varnish

Coarse pumice gel

Water and water jar

Rag

Fear and Anxiety

*"I learned that courage was not the absence of fear,
but the triumph over it."*
—NELSON MANDELA

"I'm scared I will mess up my painting!" Karen gasped, with a look of sheer terror on her face. "What if I turn my canvas into a complete disaster? What if I don't have any talent? What if I fail?" Karen had recently returned to painting after a 30-year creative hiatus. What was once her favorite childhood escape had been pushed to the back burner of her adult life. I was not surprised at all, for I had seen this happen with hundreds of my adult students.

"Karen," I asked, "can you tell me why you started painting in the first place?"

Her mood and body immediately relaxed. "As a very young child, I spent endless hours coloring with markers, painting with watercolors, and making arts and crafts projects. My parents even signed me up for a private, after-school painting class that I absolutely adored. For me, art was my safe place where I could fully express myself."

Then suddenly, her body tensed up again. "When I was in the fifth grade, I had a witch of an art teacher who didn't like me or my artwork. She constantly scolded me, snarling that I had no talent. She made it clear that I was not as good as the other kids in my class. My teacher even took one of my projects and shared it as an example of 'what not to do' in front of the entire class! To this day, I can still feel the embarrassment."

This teacher's voice had played consistently in Karen's brain for more than thirty years. As I listened to her traumatic childhood art experience, it reminded me of dozens of similar stories I had heard from other students. Whether it was the judgmental voice of a teacher, parent, sibling, or schoolmate, every person who feared creating art had a critical moment in their development when someone they trusted or respected had criticized or minimized their artistic experience and instilled a deep fear of being creative.

While the feelings of creative fear seem complicated, the brain's fear mechanism is quite simple. The fight-or-flight fear response exists to keep you safe while warning of impending danger. If you had an overly critical parent who constantly controlled and tormented your creative development, a simple word like paintbrush might make your heart race. So, while you may long to bask in the juiciness of creative bliss, your brain screams, "Art is dangerous! You will fail again! Code red, code red!"

Everyone has the power to retrain this fear response by realizing that it is merely the voice of that same bully who put you down long ago. Do you want to give your power away to this self-esteem robber, or do you want to give it to the deep creative hunger of your heart? It is time to tell your brain, "Thank you for trying to protect me, but you have it all wrong. I want to create. I want to express myself. So what if my painting is messy, ugly, silly, or I don't always know what

I'm doing? I'm going to do it anyway! I deserve to do what makes me happy, and you, fear, are not going to stop me!"

When fear and doubt speak loudly from within, it is the perfect time to ask yourself, "Why do I want to create art in the first place?" I decided to ask Karen that very question. She responded, "There have been moments throughout my life when something from within beckoned me to express my truest self creatively. During those times, the old recording of my negative art teacher always popped into my head. My love of art was battling with those negative messages." An artistic power struggle had been ruling Karen's inner world. With a tear in her eye, she continued. "I now realize that I've been acting out a memory of a little girl who had been shut down creatively and criticized by an authority figure. My fear was simply protecting me from a repeat situation."

"Karen, " I said, "I have good news for you. There is a cure for the fear you are experiencing." Karen's face lit up. "All you need are three things: acceptance, patience, and courage.

"The only way to overcome fear is to accept it as if you have chosen it. If you fight the fear, it will only grow stronger. Let the fear just be there, and accept it as best you can. It will eventually begin to dissipate on its own. The only way to reclaim your creative birthright is to run toward as many creative experiences as possible. Then be

1 Mix any shade of acrylic blue paint on your palette, or use any blue paint straight out of the tube. (This is just your first layer, so you will paint over it and it will not show in a matter of minutes!) Dip a large paintbrush into water, and then mix this watery brush into your blue paint to thin the paint texture. Apply the watered-down blue paint onto your entire canvas. Enjoy exploring brushstrokes in any and every direction. It does not matter what it looks like— your goal is full coverage of color to get rid of that intimidating white canvas that is staring back at you.

IT'S A WASH

The first layer of a painting is often what's called a wash, *a very watery application of any color you choose that you apply over the entire canvas. Have fun applying the wash by experimenting with different brushes. It will ultimately be covered with many layers of paint, some of which will be opaque and some of which may also be washes that allow this first layer to show through.*

patient, harness your inner-courage, and continue creatively expressing yourself."

As our conversation continued, Karen eventually realized that her avoidance of art had only intensified her own fear response. Within three weeks of coming to the studio to paint, she reported that her fear had lessened considerably. Within two months, her fear had nearly vanished. From time to time, Karen's inner voice still piped in with fearful thoughts, as all human minds tend to do. But she now chose to embrace her slight discomfort and move past it while paying little attention to her internal fear. Karen was now having too much fun painting to give fearful thoughts her energy!

When you feel fear creeping in, look in the mirror and ask yourself, "By listening to this fear, what opportunities am I missing out on?" Everyone wants a life that is fulfilling, meaningful, and joy filled. This is exactly what you deserve. If you are giving up opportunities that are going to make you feel happy and nourished from the inside out, then you have to tell the fear, "We are doing what makes me happy, and you'll have to come along for the ride."

Knowing that all novel experiences are accompanied by fear, remember to breath deeply and accept any passing anxiety while you are guided to create the serene landscape painting in our next project, which I call *Peaceful Night Sea of Tulum*.

Feeling afraid? Feel the fear and do it anyway.

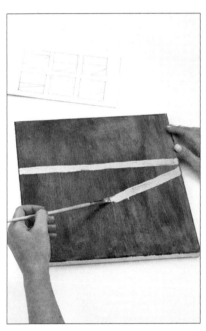

2 You will soon draw two simple lines onto your canvas. The first horizontal line you draw is your horizon line. (In nature, this is where the sea visually meets the sky). The second line is a diagonal where the sea meets the sand. To help you decide where to place these lines, grab a pencil and paper, and roughly draw your horizon line and sand line in different spots, angles, and placements. These rough sketches are called *thumbnail sketches*, and they give you the opportunity to experiment with the different possibilities in your artwork before taking the next step. You will soon use your favorite composition directly on your canvas.

3 Add a dime-sized amount of silver or white paint to your palette. Mix a few drops of water into the paint. Dip the tip of any sized brush into your paint. Using the composition that excites you most from your thumbnail sketches, paint those lines on your canvas. Remember, you can (and will!) make changes as your painting unfolds! Let the paint dry.

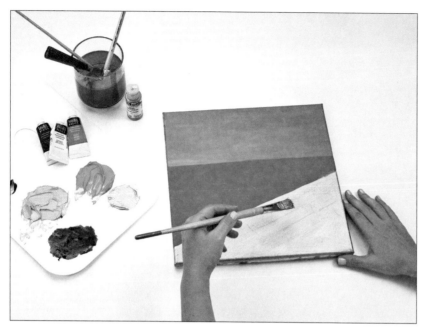

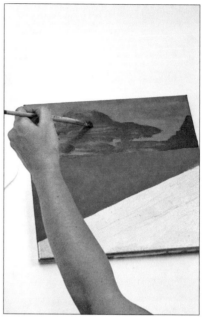

4 On your palette, squeeze out quarter-sized amounts of white, turquoise, and silver acrylic paint, and a dime-sized amount of ultramarine blue. Mix most of your ultramarine blue and white together to create a sky-blue color, adding more paint as needed to achieve your ideal sky-blue color. Using any paintbrush, apply an even layer of your sky-blue paint to the top portion of your canvas (the sky). In the middle portion (the sea), paint an even layer of turquoise. On the lower portion (the sand), add an even layer of silver. Let this dry. Meanwhile, mix new colors of blue paint as suggested below.

5 Drench a medium-sized paintbrush with water; dip it into any shade of mixed light blue, moving the brush around to mix the water and paint. Apply this watery blue to patches of the sky portion of your canvas using horizontal brushstrokes, moving from left to right and back again.

Suggested Color-Mixing Combinations

Use the suggested paint mixtures below to create different shades of blue for your sky.

white + ultramarine blue: 2 parts white, 2 parts ultramarine blue

white + ultramarine blue + turquoise: 2 parts white, 1 part blue, 1 part turquoise

white + pthalo blue: 3 parts white, 1 part pthalo blue

white + pthalo blue + ultramarine blue: 2 parts white, 1 part pthalo blue, 1 part ultramarine blue

Mix additional combinations with various amounts of each color. How many shades of blue can you mix? Explore the wonderful world of color. Each color can be the size of a full quarter or more. Be generous, I promise you will use the paint!

Optional: If you have retarder gel, now is the perfect time to use it. Acrylic paint dries quickly. Using a palette knife or paintbrush, mix a dime-sized amount of retarder gel directly into your acrylic paint to slow its drying time. This will give you wet paint to work with for a much longer period of time.

Use these suggestions to mix shades of blue for your ocean.

white + turquoise: 2 parts white, 2 parts turquoise

white + ultramarine blue + turquoise: 1 part white, 1 part blue, 2 parts turquoise

white + pthalo blue + turquoise: 2 parts white, 1 part pthalo blue + 1 part turquoise

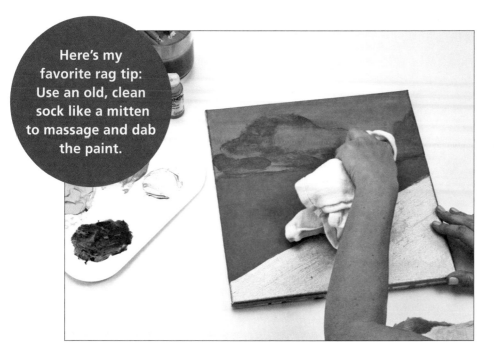

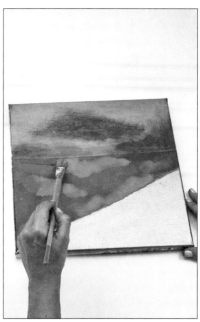

6 Clean your brush in your water jar as you allow the blue to seep into your canvas for 30 seconds. Moving your rag in small, circular motions, gently massage the newly added blue paint into your sky to take off some of the freshly added paint so the layers of color below begin to show through. Be careful not to remove all the new paint—just blend it into the canvas. Let it dry. Repeat steps 5 and 6, using a different shade of blue each time until you achieve a look you like. Let the paint dry at least three minutes each time.

7 Mix turquoise colors for your ocean. If you have paint leftover from your sky, simply add more turquoise into each color, or refer to the color mixing box on p. 58. Use these new shades of turquoise to repeat the same paint layering technique you used for the sky.

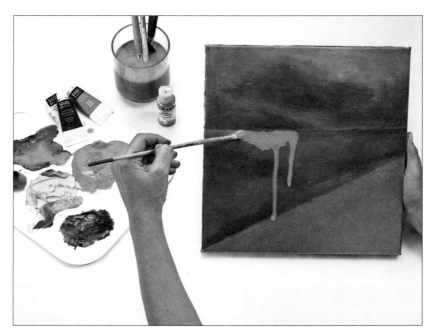

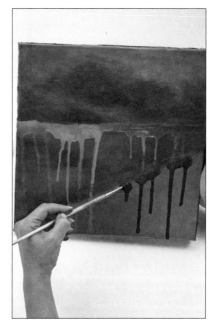

8 Add a generous amount of water to at least two of the turquoise tones on your palette. In a scooping motion, load the bristles of a small paintbrush with one shade of watery blue. Press the head of the brush onto your horizon line, and allow the watery blue paint to drip through the sea and to the bottom of your canvas. Repeat this step with any additional shades of blue that you like. Create at least five drips of paint through the sea area of your canvas.

9 Repeat step 8, this time pushing the tip of your watery paintbrush up against the line between your sea and sand areas. Let the watery paint drip down to the bottom of your canvas.

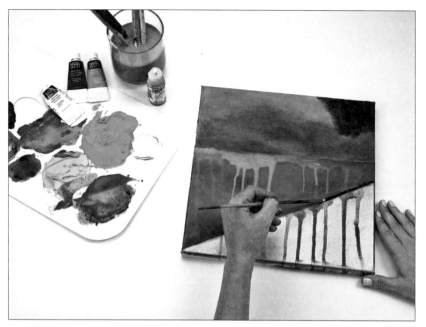

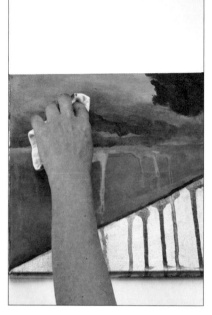

10 Mix a dark blue-purple color by combining one part ultramarine blue with one part deep purple on your palette. Dip a small- to medium-sized paintbrush into your paint and dab the dark blue-purple into the upper right-hand corner of your canvas in continuous, gentle, up-down strokes, repeating many times until you are satisfied. With the same dark color and a thin paintbrush, add thin strokes of dark blue-purple along the line where the water meets the sand.

11 Add a few drops of water to your blue-purple and, using soft paintbrush strokes, add dark touches into your sky and water. Use a rag or your fingertips to gently massage and mix the color into your canvas. Let this dry.

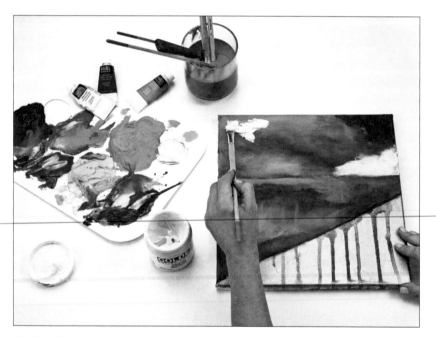

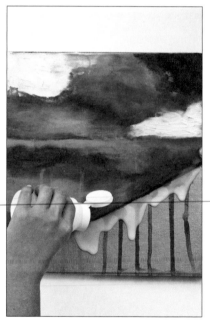

12 Bring on the texture! Apply a generous amount of molding paste to two small areas of your sky. Get messy and have fun! You may use a palette knife, paintbrush, or your fingers. Allow the molding paste to create a thick and interesting pattern. Allow the paste to dry. **Optional:** If you are a texture lover, add another layer of molding paste on top of the initial layer after it dries.

13 With a bottle of Liquitex Acrylic Gloss Medium and Varnish in one hand and your painting in the other, squeeze the gloss along the water/sand diagonal line, allowing it to pour down in an uneven flow. Lay your canvas flat before it drips off the bottom. Let it dry. Repeat.

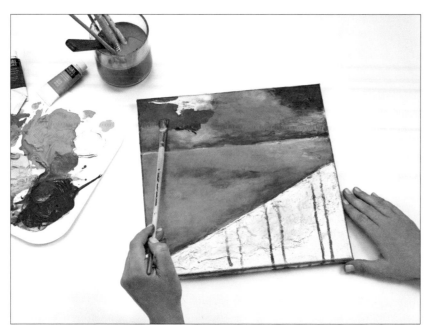

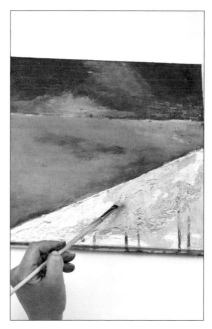

14 If you enjoy a lot of texture, repeat step 13 one more time for a total of three layers. Next, repeat steps 5 and 6, applying layers of paint over the molding paste in the sky of your painting. In addition to blending the paint with your rag, experiment with massaging paint onto your canvas gently with your fingers. My fingers are my favorite paintbrushes! Continue adding as many thin layers of blues to your sky as you like. The more water you add to each shade of blue, the more transparent it will be. The less water you add, the more opaque.

15 Add silver and light pink acrylic paint to your palette. With medium-sized brush, freely apply silver paint over the dry acrylic gloss medium. Let dry. With a small paintbrush, apply thick light pink acrylic paint on the sand area.

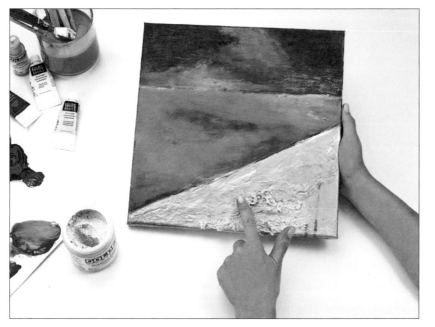

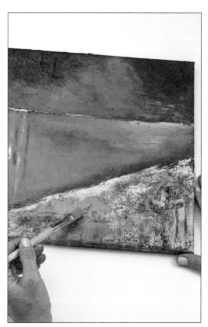

16 Using your finger, or a paintbrush, scoop out at least a quarter-sized amount of coarse pumice gel. Run your finger or brush across the bottom of your canvas, leaving the textured pumice behind. Dab another two spots of pumice to the sand portion of your canvas. Let the pumice completely dry. It will have a sandy, cement texture to it. Allow additional drops of watered-down silver and dark blue paint to drip down both the sea and sand areas of your canvas, just as you did with blue paint and the sea. Let this dry.

17 Apply layers of paint to your sand as you did to your sky and water in steps 5–8, this time using the following recommended colors: silver, light pink, and various shades of blue. Experiment with your paint applications and, at times, let your paint be thinned out by water.

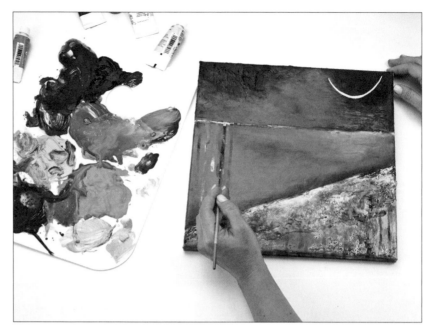

18 Using a very thin paintbrush, add a dot and a dash of white, light pink, and/or silver paint to your horizon line. You might consider doing the same on your line between the sea and sand. Either by freehand drawing or by using a rounded object, use a very thin paintbrush to draw your moon with silver or white paint. It will not be perfect! Continue to slowly paint the shape until you are satisfied. Let this dry.

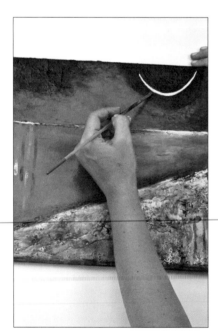

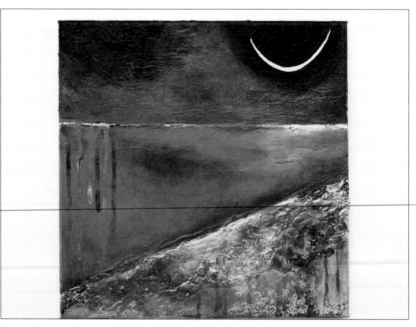

19 Mix at least two shades of light blue for the reflection. With a small brush, paint horizontal strokes of the light blue in the sea under the moon. Blend with a rag.

With the dark blue-purple tone, touch up the paint around the moon.

20 Step back at least 5 feet from your painting, and look at it from a distance. Without judgment, celebrate your creative efforts as you look at your painting. What areas do you enjoy the most? Are there areas you want to continue working on? Continue to add or change parts of your painting until you are content with the canvas staring back at you. Finish the painting by using white paint to create a thin, soft brushstroke on the horizon line to show the sparkling moon's reflection in your water.

ART & SOUL work

EXERCISE: FACE YOUR FEAR*

The key to overcoming fear is not to erase fear but to accept it while courageously moving through it. Identify a personal fear that is blocking you from a desired goal or dream. What small steps are you willing to take to face this fear? Write down three small, steady, and manageable actions that you are willing to consistently take. Practice the following tools with every action that you take in facing your fear.

1. ACCEPT: As anxiety arises in your body, passively accept the sensations within you. Do not fight the sensations.

2. ACT "AS IF": Regardless of what uncomfortable sensations are present with fear, continue your behavior as if everything is normal.

3. RELAX! BREATH DEEPLY: Breath in slowly to the count of seven and exhale slowly to the count of eleven. Practice relaxing your body at multiple times throughout your day so when you do feel fear, relaxation becomes an automatic response.

4. IMAGINARY FLOODING: Practice facing your fearful situation in your imagination. Set a timer for seven minutes, and in a relaxed and safe setting, close your eyes and see yourself approaching the fearful situation. As your anxiety level rises, continue to breath deeply and actively relax your body. Practice this daily and work up to three, seven-minute sessions.

5. SLOW AND STEADY EXPOSURE: Be sure to take small, measured steps. Many small actions taken steadily equate to big jumps over time!

If your fear is interfering with your daily functioning, seek the support of a trained professional therapist.

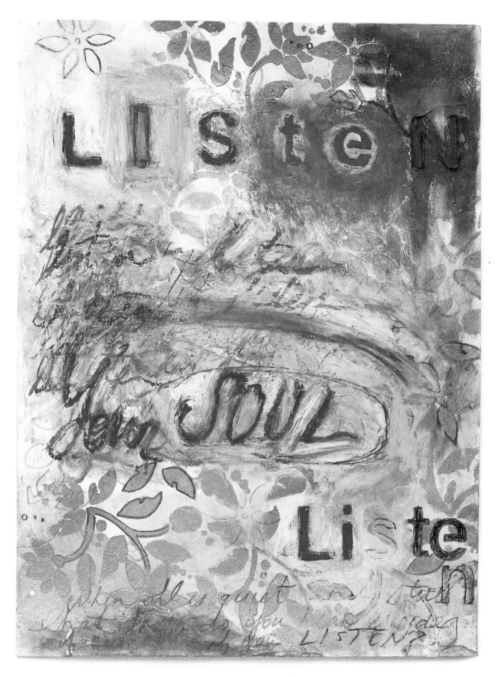

Art Journaling

MATERIALS:

Journal, sketchbook, or watercolor paper (any size)

Floral pattern stencil

Gold and silver acrylic paint

Palette

Foam paintbrushes (various sizes)

Pencil (2B–6B)

Letter stencils

Watercolor paints

Oil pastels

Assorted paintbrushes

Water and water jar

STOP! Get Quiet.

"You need not leave your room. Remain sitting at your table and listen. You need not even listen, simply wait, just learn to become quiet, and still, and solitary. The world will freely offer itself to you to be unmasked. It has no choice; it will roll in ecstasy at your feet." —FRANZ KAFKA

The pace of modern life is busier and more demanding than ever. Always on the go, it is easy to find ourselves in a constant state of running to work, social events, and family obligations while giving much of our attention to our phones, tablets, laptops, and numerous social media accounts. All too often, this drum roll of modernity drowns out the quiet whispers of innate wisdom.

In the midst of our fast-paced lives, we each have a sacred voice that speaks from the heart. Call it a hunch, gut instinct, sixth sense, or intuition. This voice offers a one-of-a-kind, personalized roadmap to the direction of your inner life. When you listen in, you receive clear direction on the fulfillment of your unique purpose.

To connect with your intuition, you must slow down, get quiet, and listen. This may be scary at first, as your vulnerabilities will begin to emerge. However, you must receive these feelings like the welcome guests they are. They deserve to be acknowledged with compassion.

Be it painting, dancing, listening to music, hiking in nature, or quietly meditating, the moments that naturally move you are the ones most likely to spark your intuition. While you may not always know where or how these moments of inner-clarity originate, you cannot ignore that something just feels right, or that you *just know.* Experiment with activities and actions that promote less doing and more being, less talking and more connecting, less running and more stillness. If you let it, the compass that exists within you will pull you like a magnet in the direction of adventure and meaning that is just right for you.

Exploring your creativity is a wonderful way to sharpen your intuitive powers. When you engage with your inner artist, you naturally compel a deeper part of yourself to come forward. You travel inside of yourself, let everything else go, and focus on your personal expression. Time to yourself, in silence, is absolutely crucial for a healthy creative life. In this silence, the external world gets quiet, and your inner voice begins to speak to you.

Painting and journaling are both wonderful ways to record the messages from this inner voice. Carve out a safe, quiet space for yourself and in this next art project, *Art Journaling,* connect with your intuition while listening to your heart.

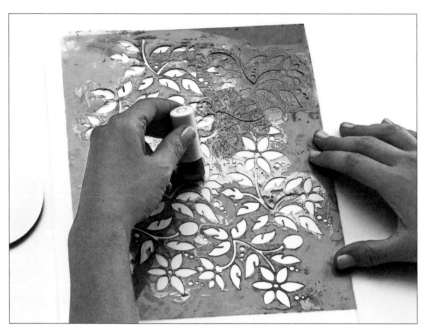

1 On a blank page of your journal, sketchbook, or watercolor paper, lay your floral pattern stencil so it is aligned with the right margin. If there is paper showing without the stencil laying over it, that is okay.

2 Squeeze quarter-sized amounts of gold and silver acrylic paints onto your palette. Dip your foam paintbrush into the gold paint, and dab it into the openings of your stencil repeatedly. Choose a few areas on the stencil to paint with silver instead of gold. Dip your foam paintbrush back into the gold paint on your palette and continue to dab onto your paper throughout the open areas of your stencil. Let paint dry completely.

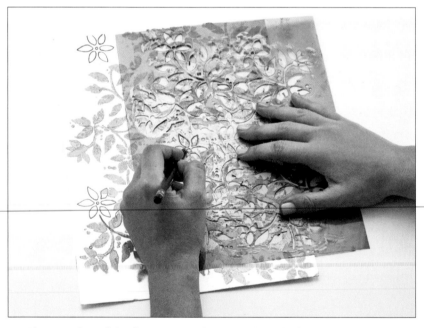

3 Remove your stencil from the paper. Check to see if you like the balance of gold and silver. Wipe paint from the stencil with a sponge and warm water and dry the stencil. (When paint fully dries on a stencil, it is difficult to remove.)

4 Choose a few of the flower stems, leaves and petals that you have already painted with your stencil on your paper. Using your floral stencil again, select three to four areas in your artwork to stencil flowers and stems again, this time with your pencil. Draw these shapes on white open spaces of your paper. Additionally, draw on top of your gold or silver painted shapes to create a layered effect.

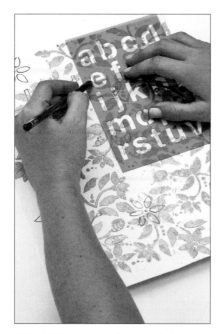

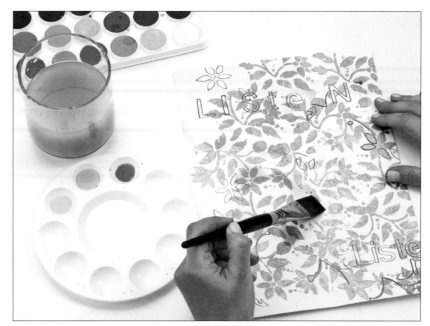

5 With letter stencils, pencil the word "Listen" on the top quarter of your paper and again on the bottom fourth. Experiment with upper- and lowercase letters. Consider stacking the last letter or two as if it didn't fit on one line.

6 On your watercolor tray or palette, mix at least three pastel colors by adding watercolor paint to several drops of water. With a medium-sized paintbrush, make large, loose brushstrokes to create organic areas of soft color throughout your artwork. Each color can have its own "pocket"—it is not necessary for the colors to mix together on your paper. Allow some areas of your paper to remain white. The watercolor paint will appear faint on your paper, creating a very subtle appearance. Allow paint to dry.

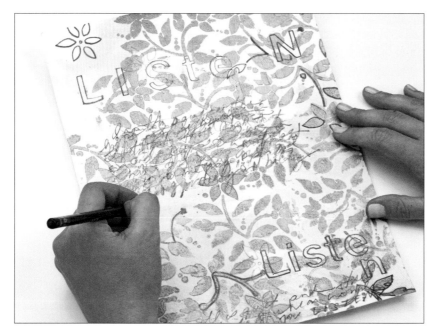

7 Pause for five minutes (set a timer!) and contemplate what "listening to your soul" means to you. With curiosity and without judgment, pay attention to the thoughts, feelings, and sensations that arise as you explore your inner world. Grab your pencil and write about this on your artwork. Perfect places to write are under the word "Listen" (in both the middle and bottom areas of your paper). You will eventually paint in both of these areas, so much of what you write may not be visible. However, you will know that it is there. Continue to write with pencil, layering your writing to layer on top of the previous layer.

8 With a white oil pastel, draw lightly throughout the middle of your paper, right over your pencil writing. Gently rub the white pastel with your fingers to blend it into the page. Repeat steps 7 and 8 at least three times to create more layers in your artwork.

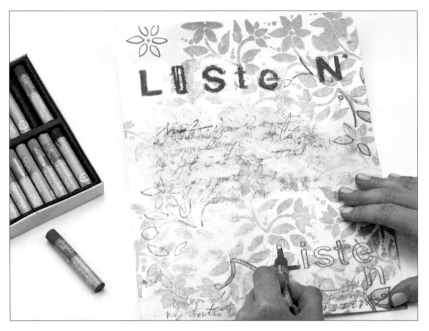

9 Roughly outline the shape of every other letter of "Listen" at the top of your page with white oil pastel (For example, outline "L," "S," and "E"). With a red oil pastel, fill in at least three letters of "Listen" at the top of your page and outline one letter.

10 With either a magenta oil pastel or magenta watercolor, fill in two of the letters of "Listen" where it appears at both the top and bottom of the page.

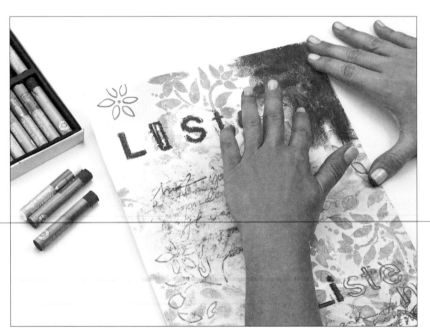
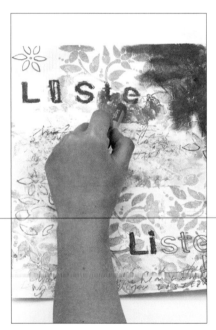

11 Add a small patch of red oil pastel to the upper right corner of your artwork and gently blend in the color using your fingertips.

12 If you like, outline the "N" in "Listen" at the top of your paper with pencil again so that it pops out. Once the magenta is dry, add a touch of white pastel surrounding the same "T" and "E" to create a glowing effect. Add a touch of white pastel to highlight these letters.

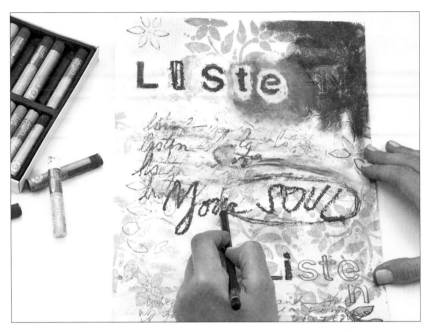

13 Starting near the top center of your artwork, write the word "Listen" with red oil pastel in small script letters. At the very middle of your page, write the words "Your SOUL" with the red oil pastel. Allow your writing to be expressive and unique to you. With a pencil or oil pastel (or both), draw a loose, imperfect circle around the word "SOUL." Focus on the energy and expressive quality of the word.

14 With pencil, color in two of the letters of the stenciled "Listen" at the bottom of the paper. Color another letter with white oil pastel, and the final letters with the color or texture of your choice.

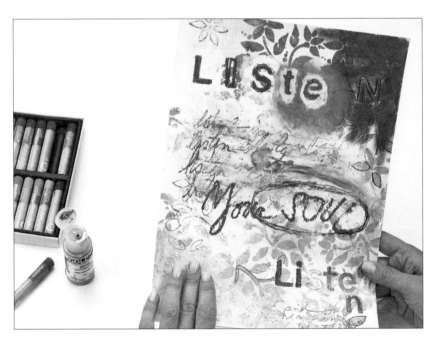

15 In the lower left corner of your paper, add dabs of silver paint and rub in with a paintbrush or your fingers. Add a touch of magenta oil pastel (or paint) at the lower left edge and rub into the paper, leaving just a trace of the color popping through.

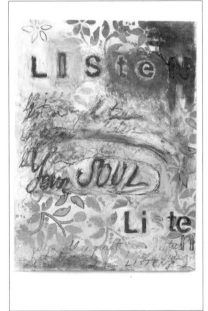

16 If desired, highlight any stenciled petals or leaves with gold or silver paint, outline with a dark pencil, or both. With the techniques you have learned in this project, continue to add any layers that feel right to you until your painting is completed.

Softening Your Heart: Making Erasing Meaningful

Erase: verb, / ɪˈreɪs / 1. Rub out or remove (writing or marks), 2. Remove all traces of (a thought, feeling or memory).

Surely you have erased before. You jotted down a few words, you made a mistake in your writing, and *whoosh*, you erased them from existence. Perhaps you have erased life experiences as well. You had a meaningful relationship with a childhood friend. She did something that deeply hurt you, and you felt you could never look at her the same way again. *Whoosh*, you erased her from your life.

When creating artwork, while there is nothing wrong with using your eraser, there is an intrinsic beauty in leaving traces of expression that you did not initially intend to create or leave visible. In art, the eraser's sole purpose is not just to "get rid of." The eraser may also be used to soften or simply lighten the intensity of a mark you have made. Picasso intentionally allowed a variety of pencil, charcoal, and paint sketch lines to appear in his artwork. Some would say that these marks were in the "wrong" place or that they were "mistakes." But Picasso's deliberate choice to not erase the "old and imperfect" offers an intimate view into his creative process. I never tire of seeing his loose and often messy looking charcoal or pencil lines showing through a perfectly painted portrait on canvas. His message comes through loud and clear: Even the earliest expressions of my heart, with all of their chaos, flaws, confusion, and disorder, are worth remembering and appreciating.

In our culture of perfection and instant gratification, we are quick to furiously erase and eradicate. Hitting the "delete" button is easy. This is not solely in our artwork; it appears in our lives away from the canvas. We want to grab our emotional eraser and wipe out the memory of previous challenges and difficult memories that left wounds in our hearts. What would happen if you softened your heart and, with compassion, searched for the beauty and personal growth that emerges from these challenges? What if all of your experiences—painful and joyful alike—have worth? Like the unique lines in artwork, instead of erasing, try the art of softening instead. You might just find a depth of beauty that you never expected!

After living in the same neighborhood for years, my nephews and niece moved out of New York City with their parents. Instead of "erasing" the emotions that I felt, I creatively expressed my feelings of both joy and sadness in my art journal.

From Should to Could

As you create your art on and off the canvas, you are presented with endless choices. What color should I choose? What direction should I go in? Shouldn't I have made more progress by now? My life should be different than it is!

The word *should* drowns you in a pool of stress and pressure. *Should* swears that you are doing something wrong. *Should* thinks it knows all of the answers.

Every time you think the word *should*, replace it with its more loving cousin, *could*. The change of just two humble letters makes a world of a difference. *Could* openly offers new and rewarding possibilities. *Could* whispers that there is no wrong way, only your unique way. *Could* gently shares new options for solving problems and never bosses you around. *Could* opens the doors to intuition and self-trust. When you leave your *shoulds* by the wayside and grab *could* by the hand, you replace your panic with peace.

As questions arise while you continue your painting, explore your world of *could*. Could you close your eyes, take a deep breath, and ask your inner-self what color you want to paint with next?

If I locked myself into how I "should" paint my experience of the changing of seasons, my approach would have been rigid and limiting. Instead, I tapped into my "could" and used bright colors, an everyday black pen, and unusual "out of the box" lines to express myself in my art journal.

Could you allow your paintbrush to dance on your canvas in ways that nurture personal freedom? Could you trust your inner-intelligence and allow your intuition to guide you toward your own North Star? I think you could.

ART & SOUL *work*

EXERCISE: PRACTICING SILENCE

Instead of talking and doing, practice slowing down and simply being. The next time you have plans with a loved one or dear friend, plan at least one hour to spend time together without speaking one word. Whether silently experiencing a meal together, slowly walking through the woods, or creating an art project side by side, carve out time to experiment and discover what it is like to listen to yourself and the world around you without uttering a word.

Garden of Joy

MATERIALS:

Recollections Mosaic Memories Paper Pad or any collage design papers/wallpaper books

Circle paper cutter (Recollections 1.5"/3.81 cm) or scissors

White watercolor paper or heavy-weight paper

Liquitex Acrylic Gloss Medium and Varnish or glue

Thin and medium-thick colored markers

White and hot pink acrylic paint

Circle-shaped sequins in your favorite colors

Pearlescent Liquid Acrylic in purple

White sharpie marker (optional)

Gold Leaf

Health and Wellness Benefits of Creativity

"Art washes from the soul the dust of everyday life."

—PABLO PICASSO

Art is not a luxury for a select few; it is a necessity for the masses. Research confirms that creativity is vital to your health. In fact, studies conclude that creative people are happier than most others. When you pick up your paintbrush, expect to experience a greater sense of purpose, relaxation, and comfort. If your health is your wealth, then creativity is your winning lottery ticket.

There is no better time than now to permanently retire your misconceptions about creativity. Whether you think you cannot draw a stick figure, do not have any creative genes, or are too busy to indulge in creativity, send those thoughts sailing once and for all. Everyone is creative. If past negative experiences stunted your creative exploration, fear not. There is no expiration date on art. You can find more joy, resilience, self-awareness, and satisfaction in your life by breaking down the barriers you have built around creative expression.

There is a direct link between creativity and mental, physical, and emotional well-being, and the therapeutic effects of art are well documented. A 2014 research study conducted by sociologist Steven J. Tepper at Vanderbilt University examined the link between art and well-being in daily life. The study found that people with a regular artistic practice score higher on well-being metrics across the board.[1] Tepper's research results showed higher self-esteem, decreased anxiety and worry, increased cognitive abilities, a greater sense of belonging, and ultimately, a more satisfying daily life for the subjects of the study. These benefits are strengthened with the frequency and regularity of practice. Creativity is the new exercise plan, and you do not have to break a sweat!

Science makes it clear: *There is a direct association between artistic creativity and quality of life.* If that is not enough evidence to send you sprinting for art supplies, also note that artistic exploration also results in biological transformation. When you are creative, levels of dopamine (your brain's "feel good" chemicals) increase in your body. Physiologically, creativity reduces tension by lowering levels of cortisol, your stress hormone. As you express yourself on canvas, your body births brand new brain cells, and as they multiply, they create new pathways. Art is even as powerful as falling in love. When your pastels squiggle through your sketchbook, the pleasure center in your brain mimics the experience of romantic love by emitting the same exact chemicals.[2]

Even simply looking at artwork is good for your health. According to a study by Professor

Semir Zeki, a neurobiologist at University College, London, admiring artwork triggers a rise in dopamine, which affects that same feel-good, falling-in-love area of your brain. Whether you are gazing at da Vinci's *Mona Lisa* or you are lost in appreciation of the painted landscape in your dentist's waiting room, the blood flow in your brain increases, and you feel greater contentment as a result.

Doctors have seen good results after incorporating art therapy with other treatments. Self-styled preventive gerontologist Dr. Arnold Bresky claims to have achieved up to a 70% improvement in his Alzheimer's and dementia patient's memories. Anecdotal evidence at senior living facilities in Great Britain shows that people who engage in artistic exploration during middle age or old age are 73% less likely to have memory problems or cognitive impairment that leads to dementia. Drawing and painting seems to activate the brain centers that sharpen memory and create new brain activity while increasing connectivity between right and left hemispheres.

Creativity is the perfect balm to soothe a lot of what ails you. In today's world, art is no longer optional. Discover ways to weave creativity into your everyday life. Your happiness, health, and well-being will all benefit from it. Allow all of your worries to evaporate as you jumpstart your own stress relief with creative endeavors.

Through the uplifting patterns and therapeutic paint application, experience the rewards in this next art project, *Garden of Joy,* as your stress drifts away and you plant your own seeds for a greater sense of wellness.

1 Choose four of your collage papers or other decorative papers. Cut four circles from each with your circle paper cutter so that you have a total of four circles per patterned paper—16 circles total. If you prefer to cut your circles out with scissors, trace a quarter, half dollar, or another circular item onto each collage paper four times. Cut out each circle.

2 On a sheet of watercolor paper or any other heavyweight paper, play with the placement of each patterned-circle "blossom." Do not glue them down yet! Have fun as you move your patterned blossoms around. Use your imagination and explore what happens when you overlap circles, allow them to go off of the page, or add or remove circles. Continue to arrange the circles until you create a composition that pleases you. You do not need to use all of the circles. Keep a few extras for making changes later.

NOTES: 1,2: Steven J. Tepper; "Artful Living: Examining the Relationship between Artistic Practice and Subjective Wellbeing"; The Curb Center for Art, Enterprise, and Public Policy at Vanderbilt University; 2014

3 When you're satisfied, apply a thin layer of glue to the back of each circle with a brush. Press down on the circle with even pressure to remove bumps as you glue it to your paper.

4 With thin markers, draw a few simple circle patterns on your paper. Repeat these motifs two more times in your artwork. Have fun drawing new "flowers" with your markers. In some places, use a skinny marker to create circles that are open, with no color or decoration inside. In other places, use a thicker marker to create dots.

5 Begin to draw stems for your collaged and marker-drawn blossoms using very thin markers for some and medium-sized markers for others. Choose a color scheme for your stems. Some may tuck behind collage circles and marker-drawn flowers, and others can be drawn on top of the variety of circle blossoms. This variation creates a sense of dimension. Not all flowers require a stem. Choose to leave some flowers floating to give your artwork a playful feel.

6 Using your fingertip or a small paintbrush, dab hot pink paint circles throughout your artwork. Your fingertip will create a great circle shape. While the paint is wet, place sequins into the middle of selected circles. The wet paint will act just like glue.

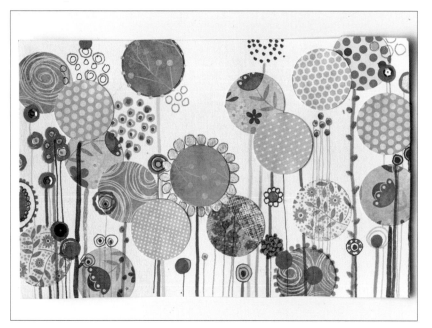

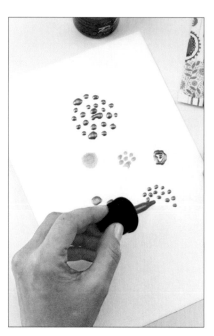

7 Now it is time to add, subtract, and make changes. Change is good! Feel free to alter any of your original, glued-down patterned circles that you no longer want. Simply glue a new patterned circle over the ones you want to change. I chose to change all of my red polka-dotted circles to patterned yellow blossoms. You can also change or erase any designs made with markers or paint by covering these areas with a white Sharpie marker or white acrylic paint applied with your fingertip or a small paintbrush.

8 Squeeze the top of your liquid acrylic dropper until it fills with purple paint. On practice paper, create a circular grouping of small dots by *gently* touching the dropper to the paper. Once you have mastered this, make dot groups on your paper.

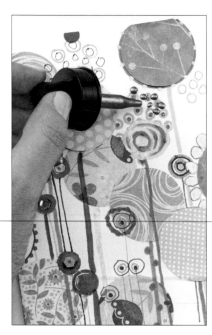

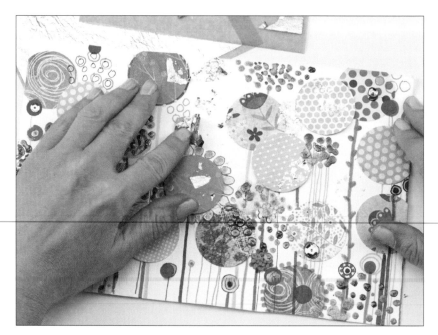

9 Return to your artwork and create a cluster of purple circle "blossoms" in at least three places of your choice. Some of the cluster blossoms may be placed on top of the collaged circles while others may go off the page to create a sense of movement. Let paint fully dry.

10 When the liquid acrylic is dry, use your index finger to dab small amounts of Acrylic Gloss Medium and Varnish or glue onto your paper in various locations throughout your artwork. Next, take one sheet of gold leaf and sprinkle small pieces or solid chunks of it wherever the glue has been placed. (Note that the gold leaf is very thin and fragile.) Wait about 10 minutes for the gold leaf to adhere to the glue. Once the glue is dry, softly wipe away any extra gold leaf with your hands or a dry paintbrush.

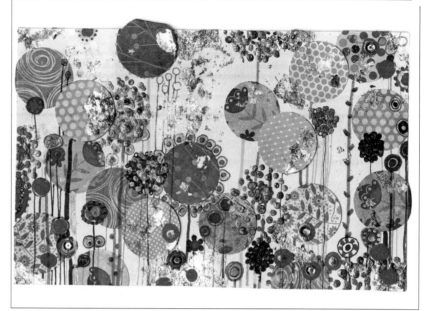

11 Continue to dab your artwork with glue and add smaller flecks of gold leaf throughout, enhancing the tops of the collage circles, the purple liquid acrylic, and the edges and corners.

12 For finishing touches, add any other liquid acrylic, marker circles, or other details that you would like. This is *your* artwork. Trust your instincts and allow your inner-creativity to guide you.

ART & SOUL *work*

EXERCISE: SCHEDULE ART ADVENTURES

Schedule a monthly art adventure for yourself. Explore a local art museum, spend an afternoon sketching in a nearby park, or take pleasure in a symphony concert. Receive the ongoing health benefits of creativity by committing to regularly nurturing your inner-artist. Be sure to write down your monthly creative dates in your calendar well in advance in order to carve out time for your personal creativity.

Meditation in Color

Meditation

"All the things that truly matter—beauty, love, creativity, joy, inner peace—arise from beyond the mind."
—ECKART TOLLE

The average person has between 50,000 to 70,000 thoughts per day. Your chattering mind throws thirty-five to forty-eight thoughts at you per minute, and where there is a thought, feelings and emotions are not far behind. In order to live a productive life, you need a respite from this constant inner noise. Luckily, there is an age-old panacea for this non-stop commentary: meditation.

Meditation is not reserved just for monks on the mountaintops. If you are eager to live a healthy and peaceful life, the practice of meditation is an antidote to the hustle and bustle that promotes a decrease in stress and an increase in personal power. The long list of its benefits spans from reducing anxiety, stress, heart disease, stroke, and high blood pressure to increasing overall happiness, psychological well-being, concentration, and focus. The scientifically proven benefits of meditation are reasons alone to carve out your own practice.

And the even better news is that any practice—including making art art!—that allows you to observe and quiet your mind is considered a form of meditation. If sitting cross-legged on a cushion is not your calling, you may find that the practice of artistic exploration is more powerful. Creativity is an active meditation where, through the act of self-expression, you learn to focus your mind, deepen your self-awareness, and let go of thoughts, feelings, and stresses while relaxing into a truer version of yourself.

MATERIALS:

4 equally sized square canvases or wood panels

Dark pencil or black pen

Ruler

Roll of masking tape

Assorted paintbrushes

Acrylic paint in various colors of your choice

Palette

Newspaper or patterned paper

Scissors

Water and water jar

Rag

Acrylic Gloss Medium and Varnish

Optional: Acrylic glass beads or another textured medium of your choice

There is an epic difference between the voice in your head and the voice of your heart, and it is crucial to move beyond the mind's chatter in order to connect with the deeper sense of who you are. The transformative practice of meditation reminds you that instead of being attached to every thought and feeling that moves through you, you can awaken to a sense of self beyond the mind. It is in this inner space that you discover a grounded reality that is a genuine reflection of who you are.

What does your own personal chatter sound like? The nonstop voice can, at times, seem like someone has stepped up to a microphone inside of your head. *What is the weather today? I wish it would be sunny already, enough with this rain! Wow, what a disappointment for my boss to have his wedding in a torrential downpour. Did you*

Are you judging me?

see what his wife was wearing last night? That was horrendous! They make a decent couple, but I hate this job. I should quit after I get my bonus. Actually, maybe it is not so bad, I get along so well with my coworkers and the company is good to me. Wow, I'm suddenly so hungry! There is nothing to eat. How I hate cooking and doing the dishes! Sound familiar? Projected over the loudspeaker in between your own two ears, this voice has something to say about everything and everyone! Through meditation, you learn to con-

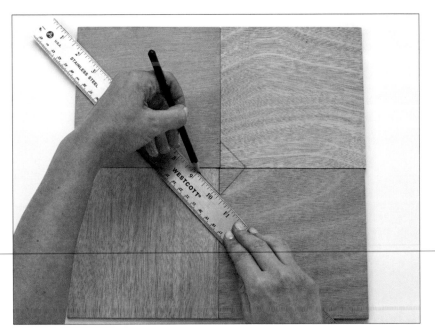

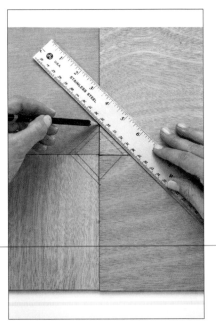

1 Place your four equally sized square panels or canvases together to make one large square. I will refer to the place where all of your four panels meet as the *center point*. From this center point, measure 1" diagonally on all four panels and mark the 1" point on all panels with a black pen or dark pencil. With a ruler, connect the four marks to create one diamond shape. Every line you add in this painting will be parallel to this center diamond.

2 Measure ¼" away from the corners of the diamond shape created in step 1, and mark this point on all four panels. Using a ruler, connect these points to create another diamond shape that is now parallel to your first diamond.

trol this monologue rather than letting it control you. With practice, you will observe and accept these sound bites like clouds passing through the sky, and their volume and impact will eventually lessen. In time, a cushion of space grows between the true you and the inner chatter. You drop out of the mind and into your heart.

Creative meditation offers an opportunity to be less controlling and much more playful both in your artwork and in your daily life. As you loosen your attachment to your concious mind, you will also untie your attachment to the final outcome of your artwork as well as to the minute details of your daily life. Meditation teaches you to allow life to unfold naturally rather than to force a specific direction that may not ultimately lead to the best outcome.

Meditation is a practice that requires discipline and commitment, and like anything else that is worthwhile, the more you give, the more you get. Do not expect instant revelation. The benefits of meditation will steadily multiply through consistent practice. A stable, trustworthy center will begin to solidify as you travel inward. When you tap into your creativity and freely express yourself, you naturally become centered in this present moment, keeping your focus on energetic brushstrokes, luscious paint textures, and the ever-changing surface of your canvas in front of you.

As you explore the meditative repetition of lines and shapes in *Meditation in Color,* allow your daily worries, thoughts, and emotions to melt away as you access a deeper, more authentic part of yourself.

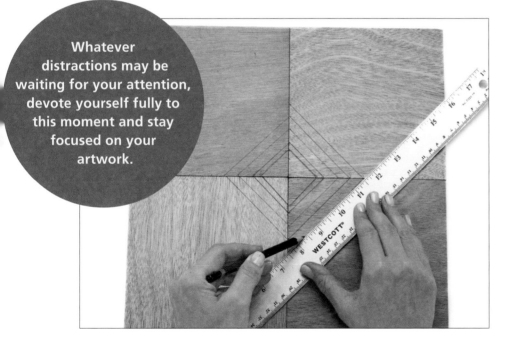

Whatever distractions may be waiting for your attention, devote yourself fully to this moment and stay focused on your artwork.

3 Repeat step 2, however this time, use a measurement of ½". Repeat this step two more times. You will continue to measure ¼" or ½" from your previously drawn diamond.

EVERY COLOR HAS A MEANING.

When you choose colors and textures for your artwork, know that each has its own unique meaning to you. Which colors do you naturally gravitate toward? Are there textures that you prefer to avoid? Color and texture are languages in and of themselves, and they have the power to speak for you through your art.

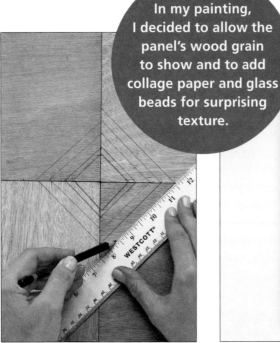

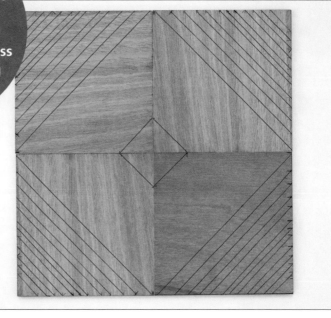

In my painting, I decided to allow the panel's wood grain to show and to add collage paper and glass beads for surprising texture.

4 Choose thicknesses that you desire, exploring a variety that excites you. You can always paint over any of these lines later. Be in the moment and allow the meditative qualities of repetitive lines to relax you as you enjoy creative exploration.

5 Now you will turn each square panel so that the triangles that make up the first diamond you created are now placed in their opposite, outside corners. Your canvases should still be touching each other to form a large square, and your previously drawn diamonds will now appear on the outer corners of your large square as well. Measure and mark 1½" from your current, new center point on all of your four panels. Connect the dots with your ruler as you draw a diamond.

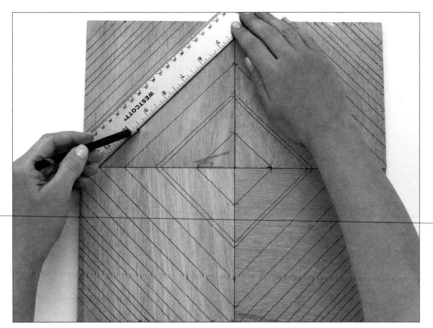

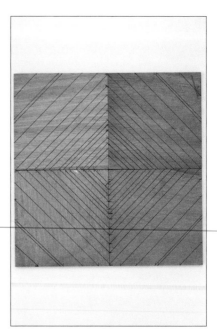

6 You will now create more parallel diamond shapes radiating from the new center point. Experiment with slightly larger measurements so that your painting will have a combination of both thin and thick lines. In my painting, the next dimensions I used are: 1", ¼", ³⁄₄", ⁵⁄₈". Connect all of your measured marks so that you end up with parallel diamond shapes of varying widths and thicknesses.

7 Turn your panels so that your original diamond is in the center. Select a color palette. I chose warm (reds, oranges, yellows) and cool (greens, blues and purples) colors.

8 Place masking tape along the outer edges of your first diamond, pressing down to ensure good coverage. With the acrylic paint of your choice (I chose red), use a small- or medium-sized paintbrush to paint the diamond as thickly as you like.

9 For now, let the paint dry completely, but do not remove the tape. Move to another section of your painting where the wet paint from step 8 will not be in your way. Using masking tape, line all outer edges on both sides of another diamond strip shape, pressing the tape down securely. Choose another paint color and apply it to the interior of your new tape borders with a texture and thickness of your choice. Let dry and do not remove the tape.

10 Repeat step 9 in at least two more places. When the paint is from steps 8–10 is fully dry, slowly and carefully remove all tape. If your tape is not cleanly removed, use a palette knife or your fingernail to scrape it away. Repeat steps 8–10 until every section is painted. If you want to leave some blank spaces for your canvas or wood grain to show through, cover them with tape to protect them while you paint. You may also leave some spaces open to cover with paper or texture mediums, as described in steps 11–13.

11 If you would like to cover any diamond shapes with strips of collage paper or newspaper, measure the width and length of the diamond strips. Use a ruler to duplicate the measurements on collage paper or newspaper. Cut out the strips with scissors.

12 Place the cut paper on the diamond; and use your scissors to trim any excess. Repeat for all four sides of the diamond, or use mixed collage papers on different sides of the diamond. Adhere with Acrylic Gloss Medium and Varnish.

13 If you would like to use any textured mediums, such as the acrylic glass beads that I used, apply tape around your chosen diamond strip as you have done previously. Apply the glass beads in the same way that you would apply paint. Do not remove the tape until it is fully dry.

14 When all of your drawn diamonds are covered with paint and/or collage, take a one-day break. The next day, look at your painting from a distance and notice what areas you like the most. Are there areas that you would like to change? Do you long to alter specific colors? Would you like to split up any of your diamonds to be thinner or combine any of your diamonds to be thicker? Without judgment, stay present to your creative process as you add to, subtract from, or edit your painting. When you sense a feeling of completion, let your painting fully dry.

15 If you prefer a glossy finish, add a thin, even layer of Acrylic Gloss Medium and Varnish with a paintbrush to your artwork. Play with the arrangement of the individual panels to create a variety of potential finished looks.

EXERCISE: WORRY PERIOD

If your thoughts are zapping too much of your daily energy, a designated worry period will help. Schedule a 10– to 15– minute worry period daily for at least six days in a row, and do your best to pick a similar time daily (ideally not just before bedtime). Instead of fighting against your mind, which encourages your thoughts to be more bothersome, you will give your mind freedom of expression.

Devote this worry period to intentionally thinking about all of your nagging and unwanted thoughts, fears, and concerns. Stir up negative mental chatter and give it voice inside of your head. Spend the full worry period thinking, and do not attempt to correct or change your thoughts. If you run out of things to worry about, recycle previous challenging thoughts. At the end of your daily worry period, take a few deep breaths to center yourself.

When similar thoughts repeat themselves throughout your day, gently remind yourself that this inner chatter has freedom of speech during your scheduled worry period. In this way, you postpone your mind rather than fight it.

While the first few rounds of your worry period may feel upsetting, in time, your mind will more naturally let go of these patterns, and it is likely that you will feel bored by the thoughts that previously plagued you. The result of this practice is that your worried thoughts, and the emotional energy attached to them, diminish greatly and may even disappear.

***NOTE: If worry or mental chatter interferes with your daily functioning, contact a trusted doctor or therapist.**

EMBRACING THE MEDITATIVE PRACTICE OF ART

When Lynn arrived at my art studio, she was eager and willing to throw herself into a new world of creative self-expression. She and her husband had relocated from New Zealand to Manhattan, and this change afforded Lynn the opportunity to explore her life like a blank white canvas. Having never painted before in her life, she decided to use art as a means of self-expression and self-discovery. Through consistent nurturing, patience, and encouragement, Lynn fully embraced the meaningful joy that was born within her through the meditative practice of art.

Three years later, Lynn shared the following:

"Art was the perfect antidote to the negativity, toxicity, and stress I was experiencing. I learned how positive, uplifting, contemplative, occupying, and captivating it is to be creative. My artistic experience became a meditation in and of itself. The creative process forces me to be myself and not judge or compare how I ought to be. I cannot pretend to be anything else but myself, because art is a reflection of the true me. My art is a metaphor for my life."

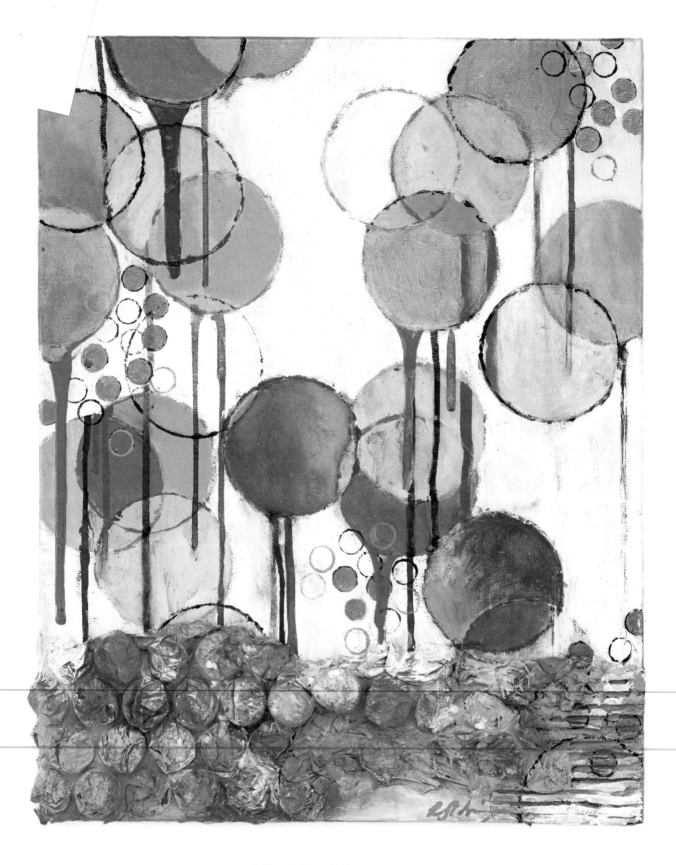

To Be Happy

Fear of Failure

"It is impossible to live without failing at something, unless you live so cautiously that you might as well not have lived at all—in which case, you fail by default."
—J.K. ROWLING

If you are to reach your life's most joyous peaks, you need to be willing to fall. Motivation is critical for success, but the fine art of failure is also an essential part of the process. Defeat, when it comes (and it will), is a circumstance rich with spiritual and emotional nutrients that you can use as fuel to grow into your best self. As you learn to overcome failure, you are led to intimately embrace the greatest hero of your life's journey: you.

While failure is woven into every human quilt, it is often feared so intensely that it leads to permanent emotional paralysis. But if you avoid failure at all costs, your path toward a rich and meaningful life is left untrodden. Instead of reaching for your dreams, giving into the fear of failure can leave you feeling unfulfilled and empty. There is no guarantee of how anything in life will turn out, but this much is true: *The only real failure is the person who gives up.*

On the other hand, when you tap into bravery despite inevitable challenges, you discover the depth of your human capabilities. Living as the empowered artist that you are, you learn that when you fail, you have the power to get back up, dust yourself off, and forge ahead in the direction of your dreams.

The timeless words of Robert F. Kennedy ring true today as much as they did fifty years ago: "Only those who dare to fail greatly can ever achieve greatly." Possibility lives outside of your comfort zone, and it is in the uncomfortable that you discover the profound.

MATERIALS:

Stretched 16" x 20" canvas (or size of your choice)

Acrylic paints in various colors

Palette

Palette knife

Assorted paintbrushes

Large, round object about 3" in diameter, such as a roll of masking tape

Small, round object about ½" in diameter, such as the cap of a paint tube

Liquitex Acrylic Gloss Medium and Varnish

Small piece of corrugated cardboard, about 3" x 3" square

Piece of bubble wrap measuring at least 3" high. The width should equal the width of your canvas.

Spare rag

Water and water jar

No matter what path of life you choose, no worthwhile human journey is devoid of difficulty, suffering or personal failure. By facing, rather than fearing, failure you can master the tools required to develop into the person you long to be. Failure has its way of sweeping through your spirit and cleansing corners of your life that are not true reflections of who you are or who you want to be. Failing also forces you to develop faith in yourself. When you fail time and time again, yet still continue to march forward, your confidence builds like a muscle inside your soul, and your heart guides you toward your goals with even greater conviction. With every recovery from failure, you walk with your head held higher.

I have failed so tragically and have fallen so hard that there were days I never thought I would have the strength to get back up. I have sprinted full speed ahead only to be stopped by brick walls that immediately sent me into downward spirals. And yet, it was amidst these heartwrenching failures on try after try and year after year, when an unexpected miracle occurred. An inner-strength emerged from within me.

When you fail, do not allow it to destroy you. Instead, use failure as fuel to thrust yourself forward in the direction of your deepest longings. The idea of failure is only as deleterious as the narrative you script in your head. Your perception, or your inner creative lens, can make a world of difference in the way you deal with defeat. How will you access your creative spirit in the face of failure? Will you cower or will you forge ahead? If you fail, will you give up or will you get up?

1 Scoop about one tablespoon of light pink acrylic paint onto your palette. Alternatively, you can mix red and white to create a light shade of pink. Add an equal amount of water into your paint, and mix together with your palette knife. Using a large brush, paint your entire canvas with this watery pink color. This is your "wash," which covers the bright white canvas. Once dry, apply a second layer of the same paint color, this time mixed with less water. Allow the canvas to dry.

2 Squeeze dollops of the following acrylic colors onto your palette: red, dark purple, orange, and aqua green.

On a daily basis, I speak with dozens of adults who are paralyzed by their relationship with failure. Dennis, for example, began his creative journey of painting after the loss of his life partner. Since grade school, he had not taken an art class of any kind, and, at age 59, he was yearning to engage in something to take his mind off his grief. What started as a distraction for Dennis ultimately grew into an important source of personal growth and deep satisfaction. One particular hurdle that Dennis overcame was his fear of failure both on and off of the canvas. Years later, now with art as a centerpiece in his life, Dennis shares, "The biggest fear is the fear of failure. With life, if you fail, you pick yourself up by the bootstraps and move forward, while on canvas, you realize it is just paint. You learn from your failures."

Your creative practice on the canvas is the perfect way to soften the blows of failure. With your paintbrush in hand, you will inevitably mix an unwanted, muddy-colored paint or accidentally drip hot pink ink through your nearly perfect painting. Perhaps you will also step back from your easel to realize that your painting looks absolutely nothing like what you had hoped to achieve. These moments have the power to become fuel for transformation rather than frustration. With time, you may realize that every brushstroke gone wrong comes with its own lesson to be learned, and you are all the better for it. Practice facing your own fear of failure in this next multistep painting experience, which I titled *To Be Happy,* and discover the rich sense of happiness that emerges through creative bravery.

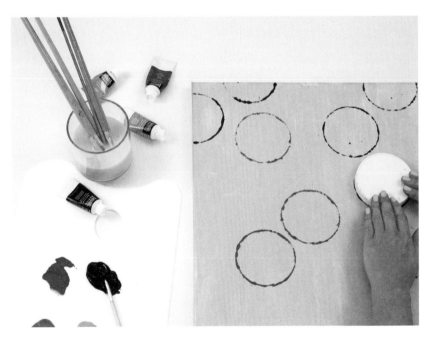

3 Choose the first color you'd like to work with (I chose red) and, using a medium-sized paintbrush, apply the paint to the outside edge of your large round object. Stamp your canvas with this object and create thin red circles of paint on top of the light pink background. Mimic the placement of the circles I have made or explore your own composition.

4 Wipe off any remaining wet paint from your large round object. Do not worry if there are remaining traces of paint, simply make sure that the paint is fully dry. Next, choose a new paint color and repeat steps 2 and 3. I chose dark purple in order to create a dark, contrasting color.

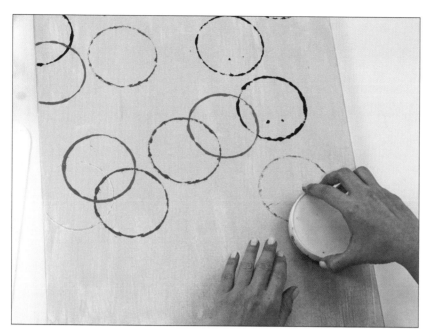

5 Repeat steps 2 and 3 two more times, wiping your object dry and using a new paint color each time. I chose orange followed by aqua green. Trust your artistic instincts and explore colors that excite you the most. Allow all circles to fully dry.

REDEFINING THE EDGES

To redefine the edges of any of the circles, repeat the stamping process in step 3, aligning your large circle with the circles that you previously stamped. The circles need not be perfect! You can always paint inside and outside of the circles to enhance their shapes later, or just accept some variations in the shapes.

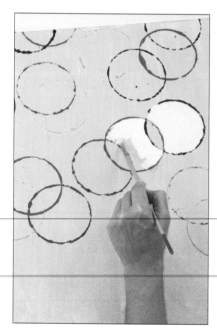

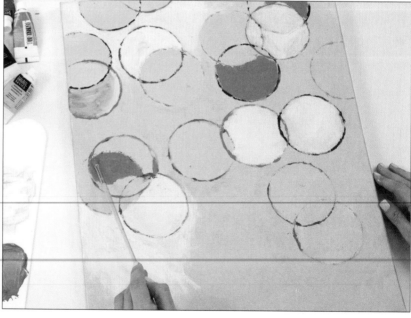

6 Mix together about one teaspoon each of yellow and white acrylic paints. Switching between small and medium-sized brushes, paint selected segments of at least five circles with thick paint in some spots and thinned paint in others. Paint outside the circles in at least two spots.

7 Mix an orange tone on your palette. Whether you squeeze orange straight out of the tube or you mix yellow and red together, choose an orange that is rich and bright. I mixed the light yellow from step 6 with a small amount of red. I also purposely mixed two shades of orange for more variation by adding more red into my light yellow in one area of my palette and mixing less red into my light yellow in another area. Alternating between small- and medium-sized paintbrushes, paint inside segments of five more circles with the orange paint, just as you did with the yellow paint in step 6.

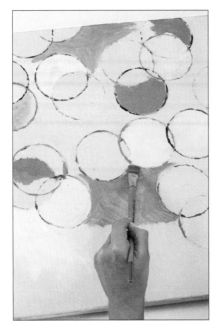

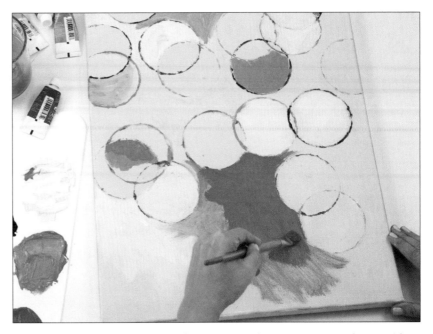

8 With the orange paint and your medium-sized brush, paint in a variety of directions in at least two large spaces between your circles. Move your brush between the circles as if you were following the current of a twisting river. Allow paint to dry.

9 Add a quarter-sized amount of magenta acrylic paint to your palette. With a medium-sized brush, paint the bottom middle half of your canvas as well as the inside of at least one of your circles.

> **Consider rubbing the pink paint with a rag to allow the previous colors to show through.**

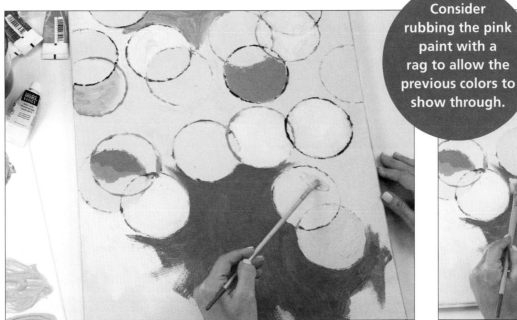

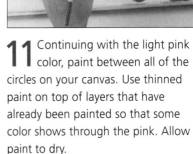

10 Apply light pink acrylic paint to your palette, or mix a light pink color as you did in step 1. Create one batch of light pink that has a heavier texture and another batch that is thinned with water. Alternating between your small- and medium-sized paintbrushes, apply varying textures of this pink (in some places thick, in some places, watered down and thinner) inside at least four of your circles.

11 Continuing with the light pink color, paint between all of the circles on your canvas. Use thinned paint on top of layers that have already been painted so that some color shows through the pink. Allow paint to dry.

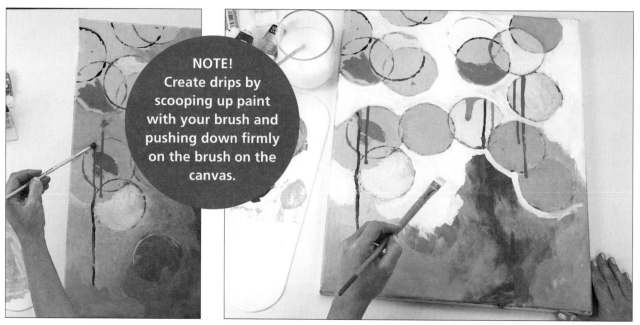

NOTE!
Create drips by scooping up paint with your brush and pushing down firmly on the brush on the canvas.

12 Mix a watered-down hot pink acrylic paint. Choose four circles where you will allow this paint to drip down your canvas from the top arch of the circles. Repeat this same technique with watered-down magenta paint. Allow paint to dry.

13 Add a generous amount of white acrylic paint to your palette. Apply a tablespoon of white paint to a separate area of your palette, and mix in at least 10 drops to thin out its texture. Dip the brush of your choice into the watered-down white paint and add it around and between your circles. Use a thin paintbrush to easily outline the circles. Use your rag to gently massage or wipe away areas of white paint so that previous colors will shine through. Paint the interior of at least one circle with the thicker white paint.

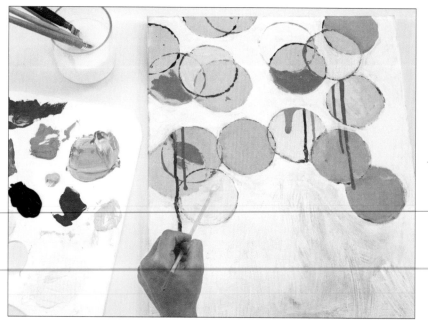

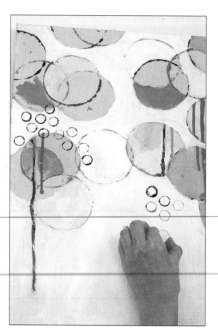

14 Mix at least two new shades of orange and two new shades of light yellow on your palette. Add some water to each to thin them out. With a small paintbrush, touch up the insides of the circles. Add touches of yellow or orange in the appropriate circles to create a spectrum of colors mixing together rather than one flat color. If you use a very watery, thinned out color on top of dried paint, you will be able to see the underneath color shining through. This technique is called *glazing*. Let this dry.

15 Using dark blue paint and a small paintbrush, paint the edge of your small, round object. Press the object onto your canvas to create 7-14 circles in three separate areas. Some circles can extend over the edge of your canvas; some may overlap the larger circles. Let it dry.

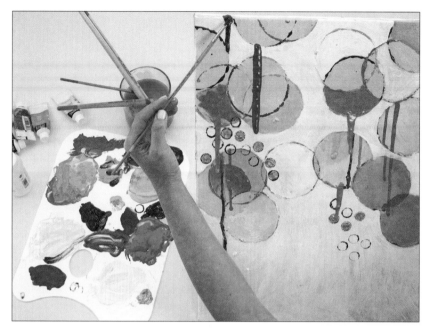

16 Squeeze a quarter-sized amount of gold paint onto your palette and, with a small paintbrush, paint the interior of the small circles added in step 15. Leave the center of four or five small circles in each cluster unpainted.

17 On your palette, mix a teaspoon of Liquitex Acrylic Gloss Medium and Varnish, five to six drops of water, and a quarter-sized amount of orange paint. Do the same with bright blue paint, then dark green. Holding your canvas vertically, apply the blue paint to the bottom edge of at least three large circles. Allow the paint to drip down your canvas (see note at left.). Let dry for five minutes, then repeat with orange, then green. Paint over any drips you don't like with white.

18 Rip an uneven piece of corrugated cardboard and glue it to the lower right corner of your canvas with Acrylic Gloss Medium and Varnish. This piece should be at least 3" high by 3" wide or the size of your choice.

19 With gloss medium, glue a torn piece of bubble wrap onto the bottom of your canvas that spans the width of your canvas and is about 3" high.

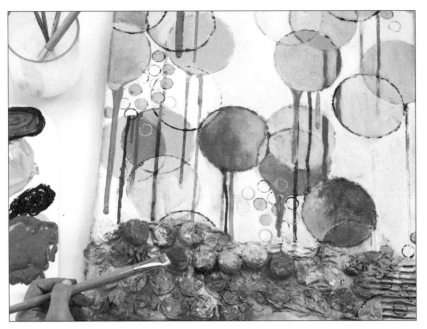

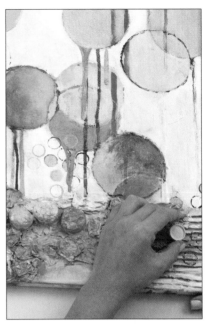

20 On your palette, mix a combination of paints in the same color scheme you've chosen throughout your painting—light pinks, oranges, magenta, white, and gold (or other colors of your choice). With a medium-sized paintbrush, freely apply these paint colors in any order on top of the bubble wrap and cardboard. Paint at least three layers of wet paint colors as they mix and blend together.

21 Re-create the small blue circles from step 15 on top of the corrugated cardboard.

FOUND OBJECTS

Art is everywhere around us! In the projects in this book, I've used corrugated cardboard, newspaper, gauze, and bubble wrap to add texture to my work. Take a look around your environment and see what interesting shapes and textures you can find. Discarded packing materials, recycled paper, and fabric remnants all are great resources.

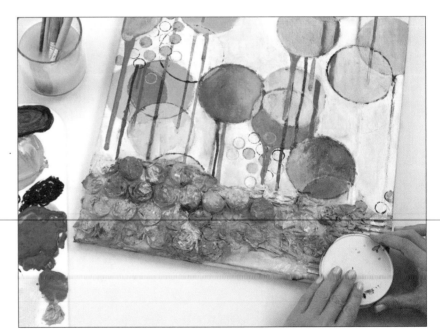

22 In the bottom right corner of your canvas, repeat step 3 using dark blue paint but stamping only the top half of a large circle.

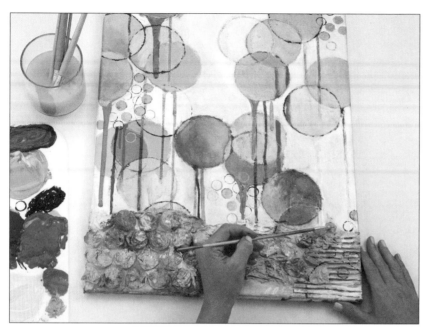

23 Add any finishing touches that you would like to your painting. From painting the interior of the blue circles gold on the cardboard to adding additional drips or watered down layers of paint, infuse your personality into your painting and make this playful artwork an expression of who you are.

24 Take a step back and analyze your work to see if you are finished. Allow this painting to be your own, and take risks to make art that is an expression of your authentic self.

ART & SOUL work

EXERCISE: DARE TO DREAM

Sit comfortably in a quiet and private space, and take three slow, deep breaths. As you exhale out loud, consciously release worries, stress, or built-up tensions in your body. Gently close your eyes and imagine one personal dream or goal that inevitably involves taking a risk. What actions would you take if you knew you could not fail? Be bold and creative in your imagination. Visualize yourself taking at least three new risks toward manifesting your intended goal. In your imagination, see yourself feeling a deep level of personal happiness as you move closer to your goal. When you are ready, open your eyes and immediately write down both your personal dream and the risks required to achieve it. Highlight one risk-taking action that you will dare to accomplish in the coming week.

Spontaneous Nature

MATERIALS:

Watercolor or heavy sketching paper

Black ink or black watercolor paint

Ink dropper

Palette with ink or watercolor wells

Assorted paintbrushes

Acrylic white paint

Water and water jar

Taking Responsibility

"Owning our story can be hard but not nearly as difficult as spending our lives running from it. Only when we are brave enough to explore the darkness will we discover the infinite power of our light..."

—BRENÉ BROWN

In this endless universe, the one and only piece of real estate that belongs to you forever is the singular world inside the confines of your skin. Nothing else is yours. Coming to this realization encourages you to reconsider how your beliefs, actions, and especially your choices affect your current reality and the potential of your future. As you wake up to this reality, it will become clear that it is not the world around you, but the world within you, that has the potential to be your greatest achievement.

When you take responsibility for your life, you accept and acknowledge that your existence today is the result of a lifetime of your own experiences, actions, and most importantly, choices. Taking responsibility invites you to grab the reigns of your personal existence and create your life by design rather than default. You can take conscious control of how you respond to the circumstances of your life. When you consciously own your life, you are truly free.

Responsibility is the real change agent in life, making you accountable to honest questions that only you can answer. Pause and ask yourself these important questions now.

- Am I who I want to be?
- What do I want in my life?
- Are my current behaviors and actions aligned with my goals and dreams? If not, what are two inner changes I am willing to make?
- What am I pretending to not know about myself?
- What old hurts are still holding me back?
- What are the things about my life and myself that I am grateful for?

As you begin to take responsibility for yourself, recognize any old habits and routines that no longer serve you. Leave your comfort zone in order to grow, evolve, and transform. In doing so, you will realize that your goals and dreams are within your control. Circumstances outside of yourself do not control your destiny. When you own your life and everything in it, from the sub-par to the sublime, you take back any power that you had previously given away. In doing so, not only will you undoubtedly feel a deep sense of purpose and pride, you will inspire others to do the same simply by being you.

It is time to willingly retire all of the built-up excuses why you cannot be the person you want to be. Those aged, crusty narratives can be fuel for new understanding and transformative change. While less-than-ideal situations will crop up in life, the meaning and value derived from them is yours to create. As your level of responsibility increases, previous tales you have told yourself may

become boring, and you may find that you prefer to pour your energy into creating happiness rather than drama.

Embodying complete responsibility does not happen in one fell swoop, a change this profound is a process. Owning every ounce of your life may be overwhelming at first. While taking pride in all of the good in one's life is natural, so is finger-pointing, self-blame, and blame when the going gets tough. Inevitably, you will discover layers of your identity that are less than admirable. Beating up on yourself for mistakes and hardships of your past is tempting. When you look at yourself in the mirror and face the more challenging dimensions of who you have become, choose to empower yourself with compassion rather than attacking others or, even worse, punishing yourself. Handle these inner spaces with care, for only through genuinely comforting yourself will you heal the parts of yourself that ache the most.

While developing into a person of awareness and action does require effort, the payoff is colossal. Taking responsibility for your entire life is a transformative choice that promises a depth of fulfillment like no other. If something is not working for you, you now know you can change it. Life's hardships take on new meaning because your relationship with them is yours to define. Look to everything that appears at your doorstep as an opportunity to learn, grow, and evolve. Take hold of the life that you want to live, and pour your creative energy into crafting the masterpiece that you, and only you, have the power to create: your life. Own your inner-world as you freely and spontaneously express your true nature in this next inspiring art project, *Spontaneous Nature*.

Creative Warm-ups: Try Something New

New experiences, new relationships, new hobbies, new travel destinations, new *anything*—the *new* welcomes you with open arms into a world of the unknown. It is ripe terrain for personal exploration.

A new opportunity can be exciting, but *new* often feels scary. When fear arises, allow yourself to take baby steps as you dip your toe into the unknown. When expressing your soul through art, you will undoubtedly encounter new art supplies that you have never used before. While you feel intrigued, the tiny hairs on your neck might also, on occasion, rise with the chill of intimidation. That's when creative warm-ups are necessary.

What are creative warm-ups? They are quick activities that allow you to explore new art materials with no attachment to a specific outcome. Whenever your hands make contact with a brand new art supply, give yourself at least 10 minutes to simply play with the new material. How does black ink move on your paper? Do you prefer a thinner or thicker paintbrush? What happens when you add water to the ink? Scribble, create lines, express yourself without attachment to what you create, and simply see what this new art material does. Through creative warm-ups, you and your new art supplies will jump into an expedition of creative inquiry without the grueling expectations and pressure of a specific outcome.

1 Before diving into a new art project, do a warm-up to familiarize yourself with your new art materials. With your ink dropper, squeeze out four or five drops of black ink onto a pallete. Choose at least three paintbrushes of various widths for your exploration.

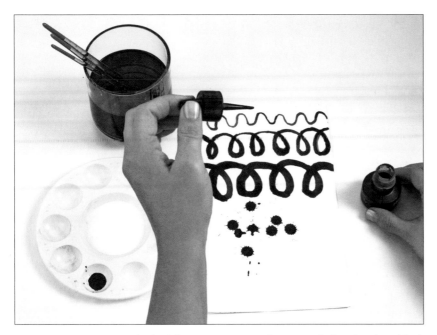

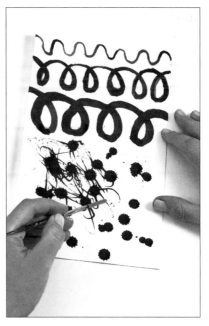

2 Now it's time to apply the ink to your paper. Dip your paintbrushes into black ink one at a time and make free-flowing lines, patterns, or movements on your paper with your brush. Next, fill your ink dropper with black ink and hold your hand at least 12" above your paper. Slowly squeeze the nozzle and let several drops splatter onto your paper.

3 Continue to explore and play with the ink through scribbles, paintbrushes, and splatters. Use the pointed end of your paintbrush to scrape into the wet ink and move the ink freely throughout your paper. Allow the ink to dry completely.

Drawing With-out Looking at Your Paper

Blind contour drawing teaches you how to see and appreciate the world around you. You exercise being in the present moment while you focus your attention on what is right in front of your nose. In today's demanding world, it is not a surprise that you might be missing the beauty around you because you are busy and distracted. Slow down, get quiet, and take in the exquisite gift of sight and the uniqueness of what you are looking at. Practice the art of seeing, and soon you will view your entire universe in an entirely new light.

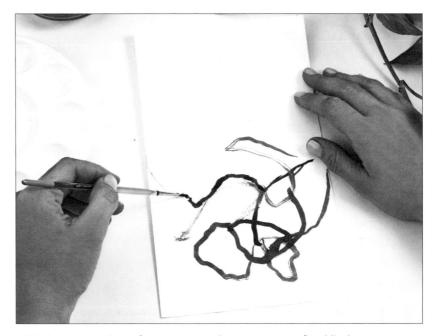

4 Using a new piece of paper, get ready to create your first blind contour drawing. Dip a thin paintbrush into your black ink. Fix your gaze onto a plant or tree. Place your brush onto your paper, and paint what you see in front of you. Do not pick up your brush and do *not* look down at your paper! Allow your hand to mimic the movement of the many leaves, lines, and overlapping shapes. Do not worry about what your artwork looks like, just practice the art of seeing as you take in what is in front of you. Create as many blind contour drawings as you like, spending just a few minutes on each one.

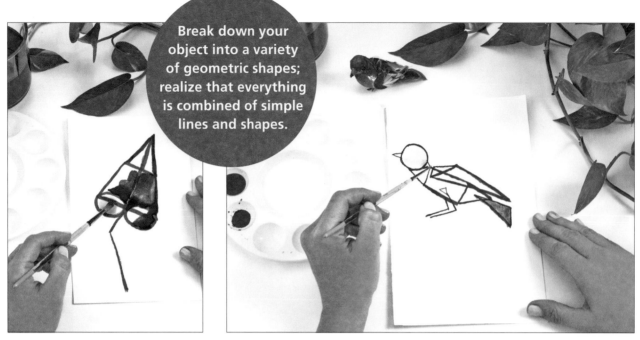

Break down your object into a variety of geometric shapes; realize that everything is combined of simple lines and shapes.

5 Focus on a cluster of leaves. What shapes are within the leaf? On a new sheet of paper and with the brush of your choosing, create a combination of circles, triangles, squares, and rectangles that create the shape of one leaf. Let this dry.

6 Using a combination of geometric shapes, paint an object or creature in nature. Place four drops of black ink in three separate wells on a palette. Add four drops of water to the ink in one well and mix the water-ink combination with a paintbrush. Add eight drops of water to the ink in another well and mix. You now have three different shades of ink. Randomly paint the three shades of ink into the different shapes on your paper. Choose another object or living creature in nature and repeat this step on a new sheet of paper.

OUTDOOR OPTION

Working outdoors lends new dimension to your work. Place your art supplies in a bag and head to your favorite outdoor spot. No need to travel far! Find a beautiful tree that inspires you. Sit comfortably and set up your art supplies with your ink near your palette and paper, and your paintbrushes withing easy reach.

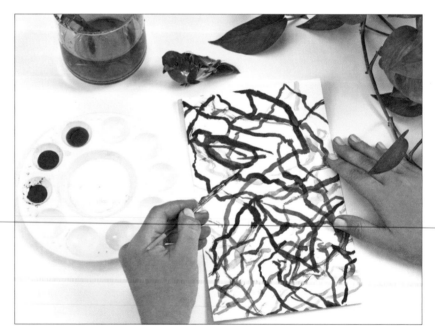

7 You will now combine the techniques of blind contour drawing with drawing the internal shapes of an object. As you look again at your inspiration leaves, notice the shapes and angles that make up the entirety of your subject matter. Dip your paintbrush into ink and draw your subject matter with the freedom and relaxation of contour drawing. Allow nature's fingerprint to give you all of the information you need as you translate what you see onto your paper. Let your brush dance throughout your paper and allow lines to intersect and overlap. Allow your artwork to dry.

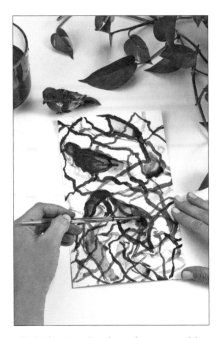

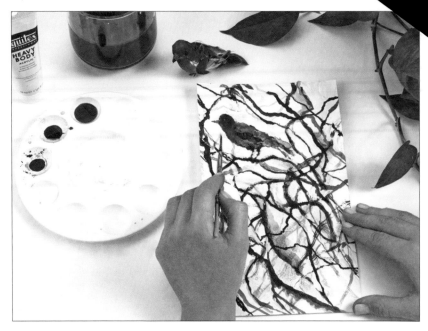

8 As in step 6, mix various quantities and colors of ink with water. Use the different colors of ink to add shading to your artwork. Let this dry.

9 Use white acrylic paint to cover any ink lines that you would like to change.. Additionally, you may use thick white acrylic paint to add small, textured brushstrokes to specific areas of your ink painting. Once the white paint is dry, you may choose to paint over it with more ink. Continue adding ink lines, shading, and white acrylic paint until you are happy with your painting.

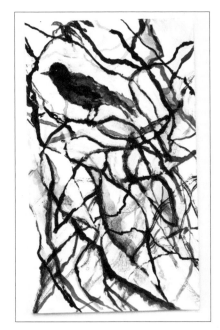

10 Voila! You have created another masterpiece!

ART & SOUL work

EXERCISE: CONTEMPLATE THE QUESTIONS THAT MATTER

Take time for yourself and reflect on at least three of the presented questions in this chapter. As you discover new questions and answers within yourself, write them in your journal and/or share them with a loved one. These are questions that do not have one-time answers. Rather, you are invited to return to these springboards of self-inquiry time and time again throughout your life.

Inner Wild

MATERIALS:

Photo(s) of wildlife

Scissors

Mod Podge or gloss medium

Watercolor paper or heavy white paper
(12" x 16" or size of your choice)

Masking tape

Watercolor paints

Assorted paintbrushes

Palette with wells

Acrylic paints in white, gold (or other metallic), and assorted colors

Water and water jar

Releasing Your Inner Wild

"Everyone has the perfect gift to give the world—and if each of us is freed up to give the gift that is uniquely ours to give, the world will live in total harmony."

—BUCKMINSTER FULLER

With an estimated 8.7 million species of animals on planet Earth, each creature has its own unique purpose. With every living being having its one-of-a-kind inner and outer beauty and individual gifts to share in our universal canvas of life, this is creative self-expression at its very best. From the fierce roar of a lioness to the yipping spotted hyenas, and the buzzing of summer cicadas, the outward expression of their nature never strays from their purpose, their *raison d'être.*

Yet humans tend to forget that we, too, are animals. We are the one and only species that has lost its way. While every other being in nature relies on its own finely tuned inner-compass to embody a life of purpose, authenticity, and self-expression, many of us have lost touch with our own inborn north stars. It is time to courageously come home to who you are by bravely releasing your own inner-wild. Nature never holds back, and neither should you.

In the majestic and massive plains of Botswana's Okavango Delta, a vast array of wildlife survives—and thrives—by living their purpose from one sunrise to the next. There is no mistaking one distinct animal for another. The lion, whose roar can be heard for up to five miles, is not afraid to make his presence as a hunter known, and power is displayed in his fearless stance. But do not be fooled by his tough nature and prowess as a predator. Just like humans, these breathtaking beings are multidimensional. Lions rely on the intimacy, trust, and protection of their pride, and they often relish with companionship through playing, licking, head rubbing and purring together.

Among the endless examples of nature's perfection stands the giraffe, exhibiting wild, raw, and authentic self-expression at its best. With her golden small horns, patterned fur, long legs and neck, and uniquely short mane, the giraffe at first appears to us as a graceful, elegant creature. The asymmetrically dotted giraffe stands tall, with her six-foot-long neck reaching effortlessly to munch on the fresh greens of mimosa and acacia trees high above. However, in her own unique way, the giraffe is a leader. With her unusually lengthy body, clear long-distance vision, and ability to peer far higher above the trees than any other creatures, the giraffe plays the role of the wildlife community's watchtowers. When a giraffe starts

running, others follow. Giraffes do not pretend to be anything they are not; they simpy are. Our assumptions shape our vision of them.

In the wild, what an animal is, why it looks the way it does, and the nature of its purpose are never questioned. A brightly colored bird alights on the back of a giraffe. With their brightly colored, scissor-like beaks, this oxpecker birds fills its stomach with the ticks and flies that plague the giraffe and other mammals, and it even promote healing by cleaning open wounds. There is no discussion, judgment, analysis, or confusion among the giraffe, the ticks, and the oxpeckers. Each knows its purpose, and like a perfectly tuned orchestra, each expresses its life force. All the while, the giraffe remain watchful, ticks quietly gulp down blood, and the oxpeckers pick away at their feast. Showing their true colors, each animal expresses their inner-wild.

Imagine the damage that would be done to our world if any one of these creatures decided to turn against its true nature. Imagine if, in a state of jealousy, low self-esteem, or unproductive comparison to other animals, the lion decided that he no longer wanted to roar, and instead, he chose to spend his days longing to have wings and the ability to fly like a bird. Imagine a giraffe criticizing herself and thinking, "I just hate my neck. It's ridiculous. Being so tall, I do not fit in with others. I just *know* that the wildebeast is judging me, and the zebra looks at me strangely from a distance." Animals do not behave this absurdly, yet human beings frequently do. How often do you find yourself wishing to be something you

1 Find a wildlife photograph that excites your spirit and makes you feel alive. If you enjoy traveling, consider choosing a photo that you have taken during a personal journey. Ideally, in the photo, the animal's head will look straight at the camera. Have a few copies available to use as "do-overs" for artistic insurance! Cut out the photo of your animal in a square shape. It will become the center point of your artwork with a lot of color and texture surrounding it.

2 Apply Mod Podge or gloss medium in an even, light layer to the back of your wildlife photo as well as to the center of the watercolor or heavy white paper. Immediately press your image onto the center of your paper with your fingers. Smooth out the photo completely so there are few to no wrinkles or bumps.

are not? How often do you turn away from the very gifts intrinsic to your individual nature in the hopes of becoming someone other than yourself? Whether envy, criticism, embarrassment, or self-loathing are controlling you, you suppress your most authentic self-expression in fear of being exposed, rejected, or misunderstood.

Let the gifts of wild nature remind you to embrace who you. You have been created with an unbelievably vast quantity of unique talents, insights, and wisdom, and there is only one you who can draw on these gifts and fulfill their promise. You were born as a necessary instrument into the earth's orchestra of life, and your responsibilty is to respect, accept, and embrace the intelligence that longs to be expressed through you. The next time you witness the blazing sun rising from the east or a chorus of honeybees humming in their comb, let them serve as a reminder to return home to yourself, to tell the truth about who you are, and to express the powerful force of nature that lives within you. With the courage of the lion, strip yourself of what is false, nurture the truth of who you are, and creatively express your inner wild. Fiercely and boldly give voice to your own roar, communicate your true self, and feel the inspiration of nature in this next wildlife-inspired art project, *Inner Wild*.

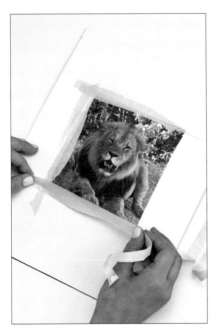

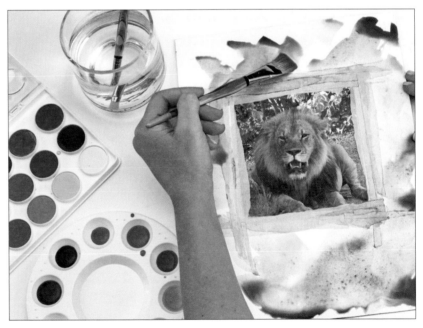

3 Rip strips of masking tape in uneven layers so that the original straight edges of the tape are ragged. Apply the masking-tape strips in multiple overlapping layers around all four edges of your square photo.

4 Choose or mix a variety of earth-tone watercolors that are similar to the earth tones in your photograph. For example, my lion has fur of gold, tan and brown, so I mixed those specific colors. With your paintbrush, combine each color with water in your watercolor palette's individualized wells. For a softer and more transparent color, add more water. For a brighter and more opaque color, add less water.

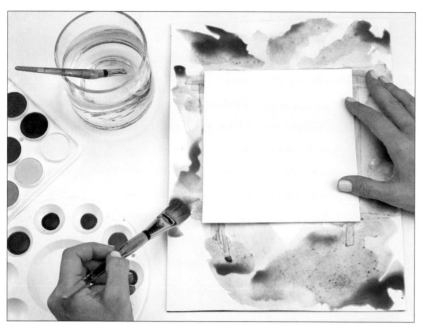

5 Using a medium-sized paintbrush, apply your earth-tone watercolor paint, one color at a time, in plentiful watery "dabs" over your entire paper. Don't be afraid to allow colors to mix together. Do not apply any paint on your animal's face or surrounding areas. To keep your animal face free of paint, place a scrap piece of paper over it for protection. Let the watercolor paint dry.

6 Using a medium-sized paintbrush, apply white acrylic paint in expressive brushstrokes on top of the dry watercolor paint. You actually paint over (and get rid of) most of your watercolor tones, but some areas of watercolors should show.

7 Using a smaller paintbrush, apply white acrylic paint brushstrokes to frame the face of your animal. From that white paint, create diagonal brushstrokes from the upper area of your animal's face to the outer upper corners of your piece of paper. Use as much paint as you want! By adding more paint, you will create more texture and energy around your wildlife image. Be sure to fully paint over the yellow color of the masking-tape strips with thick white paint while still seeing the texture of the tape in your artwork.

8 With the pointed end of your paintbrush, aggressively and expressively scrape into your wet white paint. You will scrape through the white paint and uncover areas of earth tone watercolor to show through underneath. Allow the white paint to dry.

9 Using your watercolors, mix another batch of at least four more earth tones that are similar to colors in your photo. Cover up the photo of your wildlife again with scrap paper to protect it. Drop splotches of water onto your paper with a clean paintbrush, then add the watercolor tones into the splotches.

10 Pick up your paper and angle it so that the watercolor splotches drip in diagonals from the upper corners of the paper toward the center—but do not allow the drips to cover over your animal's face! Lay the paper flat and let it dry.

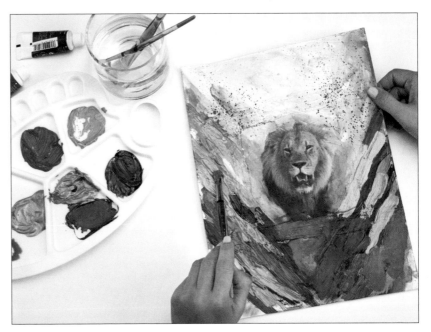

11 Keeping your animal's face properly protected against any paint, dip your paintbrush into a watercolor and splatter the color throughout, mostly in diagonal movements. [See p.46, step 8 for splatter instructions.] Repeat with your various watercolor tones. Let dry.

12 Mix similar acrylic paint colors to those you created with your watercolors. It is the perfect time to use acrylic gold paint or any other metallic color that you love. Continue by applying diagonal brushstrokes with acrylic paint, one color at a time, with a medium-sized paintbrush throughout most of your paper. Do not add paint over your animal's face nor to the top third of your paper. Apply whatever textures you prefer. While thicker paint creates more texture, watered-down paint (acrylics mixed with varying amounts of water) is thinner, softer, and more translucent.

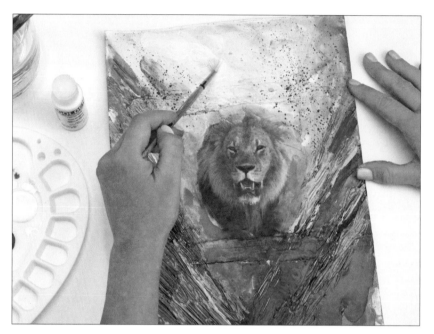

13 While the paint is wet, use the pointed end of your paintbrush to scrape into the wet paint, as in step 8. Add layers of splatters, drippy watercolors, and acrylics, scraping and adding in turn as many times as you desire. Let dry between layers.

14 Dip a dry paintbrush into a very small amount of liquid white acrylic paint. (To create liquid, add a few drops of white to thick acrylic paint). Apply the white paint to the top middle of your paper with soft, circular motions to create a cloudy, heavenly look. With your rag, massage the wet paint in small circular motions into your paper. Be sure not to paint over your animal photo.

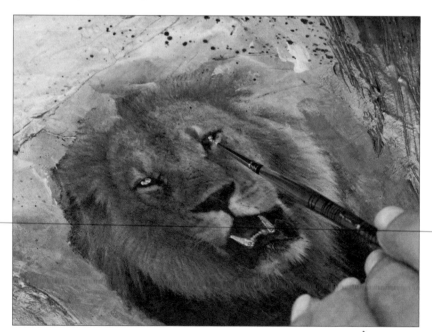

15 Decide where you would like to add paint on your original wildlife photo. Choose two or three small areas of your animal's face, such as the eyes, a small patch of fur, or the teeth. Mix the appropriate color(s) that you would like to use. The color(s) should blend in with the original color in your photograph so that the viewer can't tell the difference between the photo and the paint. Using a small, thin paintbrush, add touches of your chosen color(s) right onto your photograph.

16 Continue to add any necessary touches to your painting or repeat any previous techniques as many times as you would like. Celebrate your creative success and let yourself roar!

WHATEVER YOU DO, DO NOT GIVE UP

A successful breakthrough often follows failure. On a train from Manchester to London, the story of Harry Potter came to author J. K. Rowling's mind fully formed, and she immediately began to write nonstop. However, the wild success of this epic tale was preceded by intense suffering and personal failure. In 1992, after losing her mother to multiple sclerosis, Rowling moved to Portugal, married, and had a daughter. One short year later, she was divorced. With only three chapters of the first Harry Potter book completed, she moved to Scotland with no job and not a penny to her name. As a welfare applicant suffering through bouts of depression, she saw herself as a failure. Yet, she kept writing, refusing to give up. To describe this period in her life, Rowling shared, "I had failed on an epic scale. An exceptionally short-lived marriage had imploded, and I was jobless, a lone parent, and as poor as it is possible to be in modern Britain, without being homeless. The fears that my parents had had for me, and that I had had for myself, had both come to pass, and by every usual standard, I was the biggest failure I knew."

Upon completion in 1995 of the manuscript for what was eventually became *Harry Potter and the Philosopher's Stone,* the book was quickly rejected by twelve major publishing houses. One year later, Bloomsbury, a small, independent publisher, accepted the book and offered Rowling a tiny advance. Only 1,000 copies of the book were printed initially. Despite this modest beginning, *Harry Potter and the Philosopher's Stone* did not go unnoticed. It went on to win major awards, including the British Book Award for Children's Book of the Year. Rowling's success soon exploded, and Harry Potter claimed the spotlight. Today, more than 400 million copies of Rowling's books have been sold, and she is known as the most successful female author in the United Kingdom. Had Rowling given up in the midst of her earlier failure, millions of minds around the world would have missed out on the magical tales that she was born to create and share.

ART & SOUL work

EXERCISE: NATURE, MY TEACHER

Spend at least one hour quietly in nature. Pay close attention to the songs of the birds, the swaying of the trees, and the blazing sun. Instead of taking wild nature for granted, tune into the powerful force of life and wisdom surrounding you. Ask yourself: "How can nature teach me what I need to learn in my life right now?" Continue to remain aware and alert, and notice any seeds of clarity that appear before you. Whether it is learning to be more assertive like the singing sparrow who never holds back her voice or to sit in stillness like the mighty oak tree despite the thunderstorms it endures, nature has a wealth of inspiration to rain upon you if you take the time to absorb its wisdom.

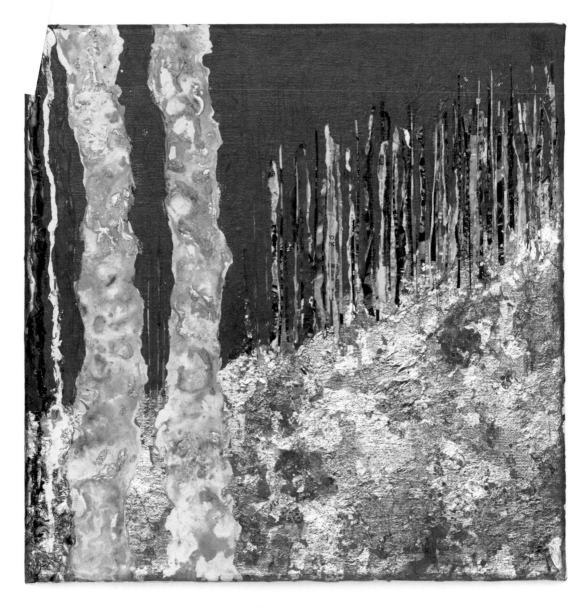

Magical Forest Series

MATERIALS:

Stretched 20" x 20" canvas (or square size of your choice)

Assorted paintbrushes

Acrylic paints in colors orange, white, and magenta

Pencil

White ink with ink dropper

Metallic acrylic inks in colors green pearlescent and silver pearlescent

Metal leaf adhesive

Gold, bronze, and silver leaf

Leaf sealer

Palette

Old magazine

Scissors

Liquitex Acrylic Gloss Medium and Varnish or Mod Podge

Spare rag

Water and water jar

Optional: Additional color of ink

Chaos and Order

"There is a crack, a crack in everything.
That's how the light gets in."
—LEONARD COHEN

Life is an ongoing journey of chaos and order. When things completely fall apart, you have the power to piece the puzzle of your life back together, often in a more meaningful, deliberate way. While order provides the much-needed stability that we all need to thrive, the gift of chaos offers a pathway towards self-awareness, and we are pushed to examine who we are, who we have been, and who we want to become. It is only when turmoil arrives at our doorstep that we learn to lean into the cracks, the heartbreak, and the constant changes of life, for it is through these very cracks that we discover the light within us. It is through chaos that you will seize the opportunity to redefine and reorganize your priorities, goals, hopes, and dreams. So too, on the canvas, expect your creative experience to become wildly chaotic, confusing, and even unnerving. Instead of running away from the discomfort of disarray, welcome and even play with it! Bask in the beautiful mess of life.

When life's turmoil strikes, our inclination is to cling to the equilibrium of order. Who would not prefer peace over suffering, clarity over confusion? In times of tumult, we suddenly ask demanding and unanswerable questions to ourselves, our loved ones, and to God: "This is not fair! I do not deserve this. I am a good person, and this should not be happening in my life. Why me?" Your patience, maturity and the supreme healer, time itself, are prerequisites in navigating towards the discovery of personal treasures found amidst life's rubble. In challenging times, we are reminded of the age-old wisdom that the only constant in life is change.

Many years ago, I was fortunate enough to have the opportunity to hike through Yosemite National Park, a pure symbol of America's exquisite landscape. As I crossed through grand meadows, lifted my eyes towards sky-high sequoias, and surrendered to the awesome power of granite rock under my feet, I felt humbled by the perfect order of life.

As I turned the corner, my jaw dropped with shock at the sight in front of me. While one quick moment prior, I had been hypnotized by nature's harmony, now, seconds later, I stood in the ashes of a horrific forest fire that had recently consumed endless acres of life. What was once a sea of green had burned into a cemetery of charred, bare and blackened tree trunks. An immediate sense of mourning swept over me as I envisioned the total chaos of this raging, lava-like forest fire, engorging every last sign of life in its endless reach.

Seeing my face, my mountaineer and botanist guide understood my discomfort. And yet, while my untrained eye perceived the fire as a story of destruction, I soon learned that what appeared as a chaotic and dramatic tragedy was actually nature's way of healing itself while bringing forth the miracle of new life. The thick smoke and raven-

ous flames I considered to be nature's own horrific pandemonium was, in fact, a necessity for forests to consistently blossom, regenerate, and thrive.

My guie explained to me that only in the heat of a raging forest fire will certain plant and tree seeds germinate. Without those high temperatures, the seeds would remain encased in their pods. Phosphorus, the dusty white remains of the former forest, adds critical nutrients into the soil. The chemicals from the trees' charred wood nurture the growth of native plants and flowers, some of which lie dormant for years, even centuries, and are suddenly awakened only by fire. In fact, some of nature's most jaw-droppingly colorful blossoms only appear in the aftermath of massive flames.

Chaos, a natural and necessary dimension of life, is the catalyst that breeds new life, growth, and strength, not only in the forest but just as powerfully, in the landscape of your soul, in the expression of your artwork, and in the creation of your life. In time, as the blazes of inner chaos settle, your own personal seeds of potential will split open to birth new life to your spirit. New roots, new branches, and beatiful bright new leaves freely spring forth from what initially seems to be a devastating accident. In chaos's aftermath, you are ripe with growth opportunities, new insights and personal transformation.

How will you learn to thrive and grow when the fires of life sweep through your emotional landscape? When you encounter chaos, how will you move forward in the face of the mess that is staring back at you? Chaos is a powerful catalyst for inspired change, reevaluation, and ultimately, the creation of a deeper and more conscious, meaningful life. Painting offers the perfect terrain for the practice of embracing the paradox

1 With a large paintbrush, apply a thick layer of orange paint onto your entire canvas. While the paint is still wet, with the pointed end of your paintbrush handle, carve a line to represent the jagged slant of a mountain. Allow your line to be curvy and imperfect, purposely letting your hand shake to make an uneven line. Let the first paint layer dry.

WHY THE ENTIRE CANVAS?

Get rid of the white! That big white canvas staring at you is intimidating. Does your first paint layer matter? Really, not too much! You will paint over it and most of it— sometimes none of it— will not even show in the finished work. Don't think too hard about your first layer, just jump in and have fun.

of chaos and order. Will you allow areas of your artwork to be less orderly while other aspects are visually calmer and more structured? Will you continue forward with compassion when one moment, your feel your painting is brilliant, only to be followed by the next moment where you are repellled by the mess staring back at you? As you practice the tango of chaos and order in your artwork, remember to apply this same graceful dance to your daily life. When chaos appears, embrace the challenge, and even failure, as a chance to develop new insights, life lessons, and personal wisdom. In moments of order, enjoy the stability while charting new waters for future risks and leaps. In the art project that follows, which I called *Magical Forest Series* in honor of the landscape I witnessed at Yosemite and the important lesson I learned there, allow the paradoxes of your life—chaos and order, sadness and joy, fear and courage—to fuel the fire of inspiration as you create a magical, expressive painting.

I DARE YOU! Loosen up and try to draw the trees in Step 2 with your nondominant hand.

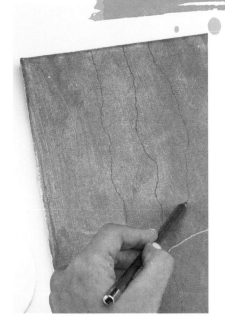

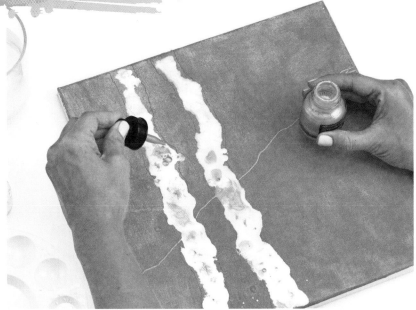

2 Pencil in two tree trunks on the left side of the canvas. Each should be about 1½" wide with at least 1" between. Allow some areas of your tree to be thicker and others to be thinner. With a clean paintbrush, coat the inside of your trees with water.

3 Using a dropper, drip white ink, green pearlescent acrylic ink, silver pearlescent acrylic ink, and watered down white acrylic paint into your watered-down tree shapes. Let the colors mix together. You will not be able to control how the paint moves—just relax, enjoy the journey, and trust the process! Let the paint dance, move, and marble. It will look different when wet than when dry. Let this layer dry fully.

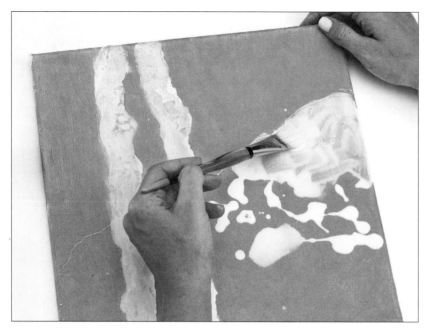

4 With a paintbrush, apply a layer of metal leaf adhesive everywhere on your mountain except for your trees. Add the adhesive in between, to the left, and to the right of your trees going right against the edges, using a smaller paintbrush if needed. Do not add the adhesive to the inside of the actual trees themselves, rather only in between them. Wait 20 minutes for the adhesive to dry. Be patient! When the adhesive is dry, it should feel tacky to the touch. If you do not feel the tacky senstation, wait another five minutes.

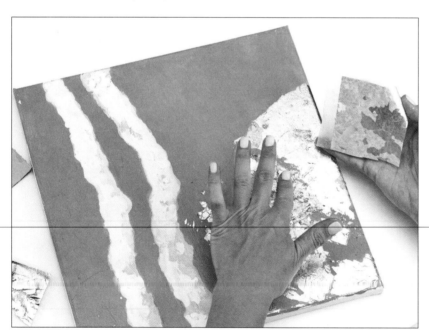

5 When the metal adhesive has the tacky feel, apply pieces of gold, silver, and bronze leaf to the entire mountain area. Sprinkle chunks of leaf everywhere on top of the adhesive. There will be areas where the orange shows through—you want that! Wait 5 minutes. With a dry paintbrush, brush off all of the extra leaf. If there are areas where the leaf didn't stick, use your fingers to stick on smaller pieces of leaf in those open spaces. If necessary, repeat steps 4 and 5 in smaller areas where the leaf did not stick.

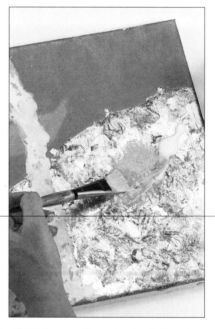

6 With a medium-sized paintbrush, apply leaf sealer to your palette and apply a thin, even layer of sealer to your mountain of metal leaf. It will have a milky tint when wet but don't worry, it dries completely clear.

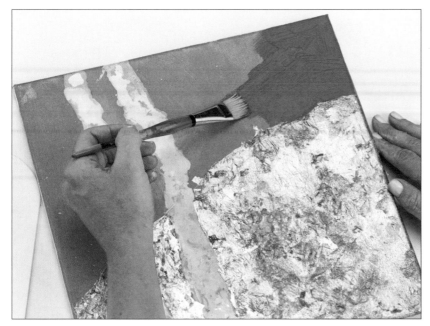

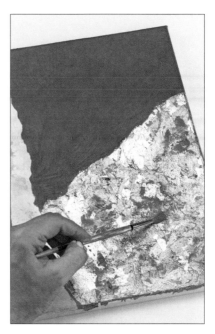

7 With a medium-sized paint brush, paint the sky above the mountain with magenta acrylic paint. When painting near your trees, use a smaller paintbrush. Accentuate the knobs and curves of your trees by allowing your brush to butt up against, and even redefine, those areas of your trees. If you would like the orange to show through the magenta in the sky, apply a watered down layer of magenta; if you prefer a thicker texture, apply it straight out of the tube. Consider more than one layer if you enjoy a textured look.

8 Mix water with the magenta acrylic paint on palette to create an extremely watery blend. Dab touches of this onto the gold/silver/bronze-leaf mountain with your finger tips or a paintbrush. Remove some of that paint with a rag as desired.

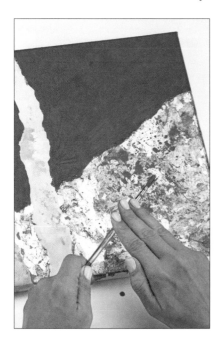

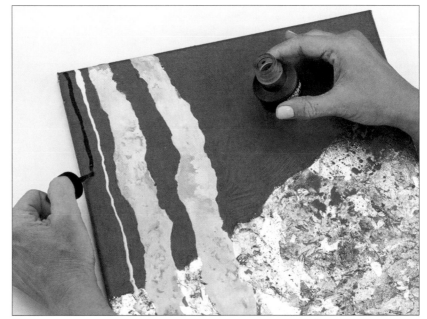

9 Dip a small paintbrush into the watery magenta, and splatter the gold/silver/bronze leaf mountain by holding the paintbrush parallel to your canvas and tapping the stem of the brush with your alternate hand. (See p. 46, step 8.)

10 To the left of your two main trees, apply a skinny straight line of white ink from the top of your canvas to the bottom with a paintbrush. When that dries, choose another color of ink or acrylic paint and, with a very skinny brush or an ink dropper, add another line from the top to the bottom. These line represent trees. **Optional:** Continue to add more skinny trees. If you prefer simplicity, add two or three lines total. If you prefer to have more, let the first three lines dry fully before adding another layer of tree lines or else the colors will all mush together and become muddy looking.

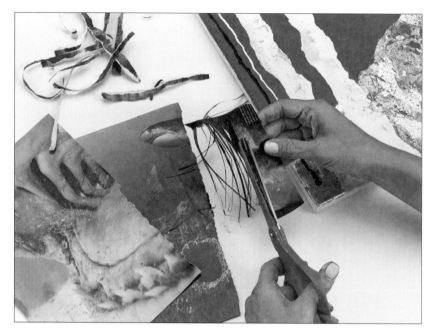

11 Flip through an old magazine and look for pages that have interesting textures and colors. Tear and cut several thin strips from these pages. They should have varying widths yet all be quite thin.

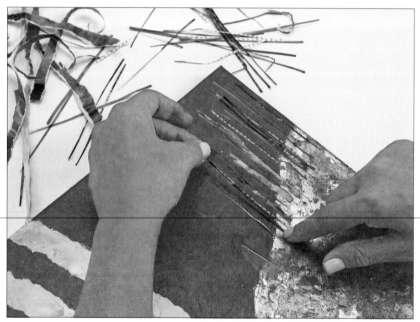

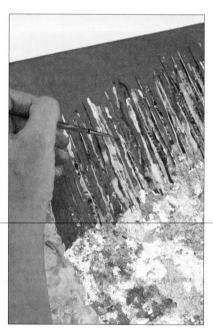

12 With your fingers or a paintbrush, apply a think coat of Liquitex Acrylic Gloss Medium and Varnish or Mod Podge to the far right of your canvas, just above the metallic leaf mountain. Add torn and cut strips of paper to the canvas by laying them over the Mod Podge. As you continue to glue on the strips, layer them over one another so that there are different thickenesses, textures, and colors showing through. Continue to collage paper strips throughout the entire painting, including a few very thin strips in between your two main trees. Use more for a thick forest of strips and less for a sparser look.

13 Using a skinny paintbrush and magenta paint, create extremely thin lines in between selected collaged tree strips to evoke a feeling of the sky poking through the trees. You might paint lines or even occasional dots depending on how thick you want your forest to appear.

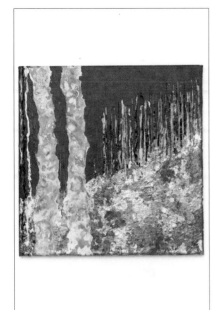

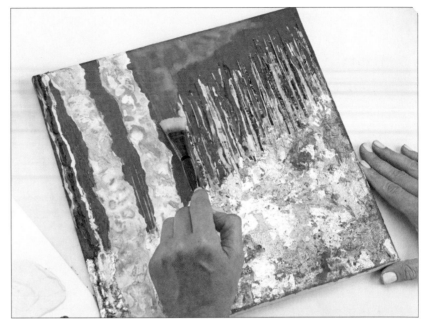

14 In my painting, I needed to touch up various areas with magenta paint. I also needed to touch up some areas of the hill with gold, bronze, and silver leaf. I simply repeated earlier steps in this project to do so.

15 Once the painting is completely dry, apply a thin layer of Acrylic Gloss Medium and Varnish with a paintbrush onto every part of the painting *except for the metal leaf mountain*. (Do not apply gloss on top of metal leaf; it will change the color of the leaf.) This will give you a finished glossy appearance. If you prefer a matte look, do not apply the gloss.

SERIES IDEA

If you would like to create a series of multiple paintings with this theme, tweak the steps for this project. Introduce a brand new palette of paint colors and change the composition by placing your large and small tree trunks in different locations. Release your creativity and create your own magical forest series of paintings!

ART & SOUL work
EXERCISE: GRATITUDE CHALLENGE

Commit to a personal, 30-day gratitude challenge. Gratitude is an attitude, and this exercise will help you to create positive, anchoring roots in your life regardless of whether you are in a period of chaos or order. For thirty days straight, write down three things that you are grateful for. Every day, choose three new things; do not repeat anything you have written down previously. This creative tool is a supportive and uplifting practice for all of the times of your life, and it will come in handy especially during seasons of personal chaos. Train your brain to seek out glimmers of hope even while the forest fires are blazing, and you will create your own silver lining to nurture new seeds of hope and growth.

If you would like to take this challenge one step further, invite at least two friends to join you in your gratitude challenge, and email your gratitude lists to each other daily. Not only is this a meaningful way to build on the stability of your relationships, you will also witness how the power of gratitude spreads and inspires like wildfire.

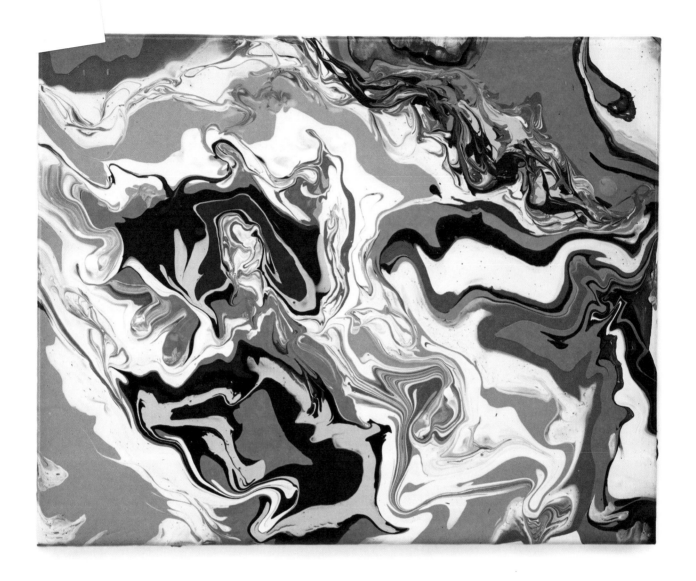

Goodbye, Perfectionist

MATERIALS:

Stretched canvas (size of your choice)

Acrylic paints

Liquitex Acrylic Gloss Medium and Varnish

Plastic recyclable cups or Recycled containers/jars

Water and water jar

Palette

Palette knife

Medium or large paintbrush

Letting Go

"To be beautiful means to be yourself.
You don't need to be accepted by others.
You need to accept yourself..."
—THICH NHAT HANH

Perfectionism is self-destructive to your success as a creative human being. The perfectionist is trapped in a tennis match between unrealistic expectations and the ensuing disappointment that comes from striving toward the impossible. Even when tireless efforts succeed, perfectionism convinces you that you are never, were never, and will never be, good enough. The perfectionist pours their last drop of energy into controlling every move, perhaps with the unconscious hope of receiving large doses of love and acceptance in return from the outside world. Striving for lofty, impossible goals that are not attainable and obsessing over nonstop personal achievements is a fast track to frustration, disillusionment, and anxiety.

Here is the good news: No one is born a perfectionist. When you appoint creativity as your spiritual teacher, you bid farewell to perfectionism and slide compassion, acceptance, and forgiveness in its place. This necessary creative shift alone has the power to transform the entire canvas of your life.

Through the practice of acceptance, you can refuse to continue living in the straight jacket of perfectionism and its downward cycle of self-abuse. Accept all of the layers of yourself, from the fabulous to the flawed. As you make up your mind to be compassionate with yourself, you actively choose your highest good rather than sabotage yourself with unrealistic expectations. With this sense of self-love, you can kiss keeping up with the Joneses goodbye, and focus on what feels meaningful, purposeful, and nourishing to you instead. Compassion and acceptance urge your humanness, especially all of your imperfections, to come forth so that you are able to play a more empowered and joyful game of life.

Tap into your creative life force and address any toxic undercurrents of perfectionism. In the secret cobwebs of your mind, you may find the perfectionist's core fear—the sheer terror of making a mistake. In reality, it would be a crime to be robbed of your mistakes! Personal errors are the fertile ground in which you learn to become a better, more authentic version of yourself. Your inner perfectionist deserves the healing required for you to emerge as the strong, multifaceted, perfectly imperfect artist that you are.

Now is the time to embrace your flaws. Rather than registering errors as failures, use your creative power to see these missteps for what they truly are: opportunities for personal evolution and meaningful growth. Utilize your creativity to develop a new relationship with mistakes, one that is life affirming rather than self punishing.

You can, and should, continue to strive for excellence while setting exciting life goals, as long as

you know that many things will not turn out the way you wanted and planned for them to be. No one and nothing is perfect. It is a given that you—and everyone else!—will make errors along the way. Practice acceptance and compassion and align your behavior with what brings you understanding rather than judgment, love rather than fear, and satisfaction rather than self-ridicule. There is no perfect masterpiece, even among the famous works of art hanging in museums and galleries All that exists is a blank, open white canvas where you are invited to be yourself, express yourself, and be a pilgrim on the path to the most authentic you.

Reminding yourself that there is no right or wrong in art, bid your inner-perfectionist farewell as you surrender to the unknown and gloriously enjoy pouring luscious paint on your canvas in this exciting art project, *Goodbye, Perfectionist.*

The Art of Letting Go

Toss your perfectionism overboard! It is time for you to end the battle with a surrender. The simple act of pouring your paint forces you to let go. You hand over the control you exert over brushstrokes, and instead allow the paint to take on a life of its own. As colors and textures dance, twist, and twirl on your canvas, you can see that beauty emerges through creative risk-taking. Even if you wanted to, it is impossible to control the level of detail in this piece of artwork. The paint itself is in charge.

While perfectionism says you will never be good at anything unless you control it with a suffocating grip, expressing yourself creatively brings joy, spontaneity, and fulfillment. Do not judge, rush, or control your creative process. Rather, surrender to the journey. Counteract any negative thoughts by getting lost in the meditative flow of your paint. Let go of your need to control and watch the canvas of your life become a fuller and more enjoyable expression of who you are.

BE PREPARED
Paint will likely run over the edge of your canvas, so protect your work surface with a drop cloth.

1 Choose a palette of at least four to five acrylic paint colors that inspire you. Use paint that is either straight out of the tube, custom mixed, or a combination of both. I chose white, silver, peach, aqua, and navy blue. In a separate container for each paint color, mix one part acrylic paint with one part Liquitex Acrylic Gloss Medium and Varnish and 1/3 part water. Mix thoroughly with a palette knife or paintbrush. **NOTE:** Based on the consistency of your unmixed paint, you may require more or less water and Acrylic Gloss Medium and Varnish. The mixed paint should be the consistency of honey.

2 Place your canvas face up on a flat surface. Starting with the color of your choice, pour about ¼ of the paint mixture from your cup onto the center of your canvas so that the paint slowly expands outward. **NOTE:** Your paint will always be wet when you add the next color.

3 With your next color, pour the paint mixture onto the center of your canvas again, directly inside of the first color from step 2. This will push your first color outward while allowing your new color to be the center.

4 Choose a third color. Pour your paint mixture into the center of your canvas right into the first two colors. You will see three circle-like shapes slowly expanding from the center to the edges of your canvas.

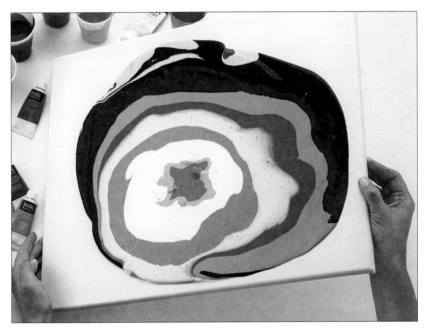

5 Repeat the pouring process with a fourth color. Continue to pour different colored paints into the center of canvas until you have a large pool of paint.

6 Slowly and gently lift one side of your canvas ever so slightly. Your wet paint will begin to move and the colors will begin to mix.

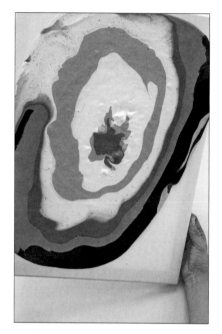

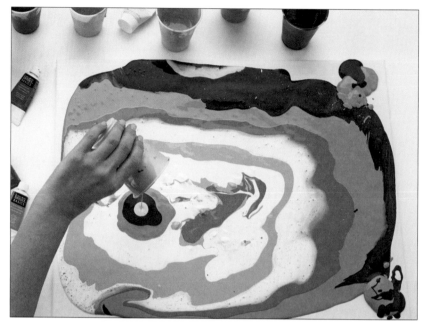

7 Repeat step 6, this time lifting another edge of your canvas. Continue lifting and dropping your canvas from different angles while your wet paint mixes, moves, and creates new patterns and designs.

8 If there are areas of your canvas that are still uncovered with paint, choose another color—either one previously used or a new color mixed as in step 2—and pour it into the spaces as you did in the previous steps. If you would like to continue adding more color to create new patterns, choose any areas on your canvas to pour in mixed paints. With each newly added color, repeat steps 6 and 7, and enjoy the fluid movement of your paint colors coming together.

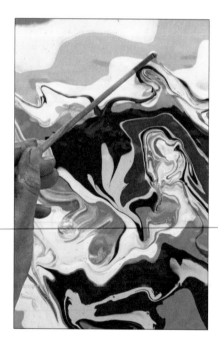

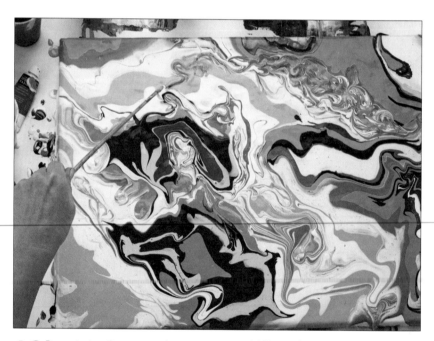

9 Lay your canvas flat again. If you would like to create a marbleized texture on your canvas, choose one area of your painting to explore. With your palette knife or the pointed end of a paintbrush, insert the point into the wet paint and slowly drag it through various colors on your canvas.

10 Repeat step 9 as many times as you would like. When you are happy with the movement of the paint and the look of your painting, lay your canvas completely flat and allow your painting to dry overnight.

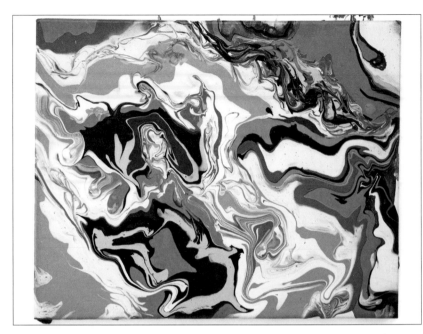

11 When your canvas is completely dry, your painting may look slightly different than it did when wet. To create the same glossy appearance you had before the painting dried, pour a quarter-size amount of Liquitex Acrylic Gloss Medium and Varnish onto your palette. With a medium or large paintbrush, dip into the gloss medium and apply a smooth coat onto your dry painting. Do not mix the gloss in with your paintbrush. Allow it to dry completely. **Note:** When applying your gloss, it may have a slight iridescent tint to it. Once it dries, it should be clear.

> **ONE MORE TIME!**
> *You can achieve an even greater depth to your painting by adding more layers once the initial painting is dry but before applying gloss. The dry painting will become a background to your newly added paint. You can begin in the middle of your canvas as you did the first time, or you can start in one of the corners.*

ART & SOUL work

EXERCISE: PRACTICING GRATITUDE

Keep a small journal in your bedroom, and every night before you go to sleep, thank yourself for five things that you did well today. While this list may include accomplishments, think beyond daily goals and dive into the rich seas of your unique personality. Perhaps you took a new risk, sketched a new drawing, or took a much-needed breather from a stressful day to watch a beautiful sunset. Celebrate the accomplishments of not only what you did, but also more importantly, *who you are*. Continue to add to this list daily.

Important: There is no place for criticism or judgment in this exercise. Of course we can always improve, but the point of this exercise is to be grateful for what you were able to do today. Beware of the perfectionist trap of telling yourself, "I can do this better next time." Instead, bask in the beauty of who you are today and the gifts you shared with the world or that you gave yourself today.

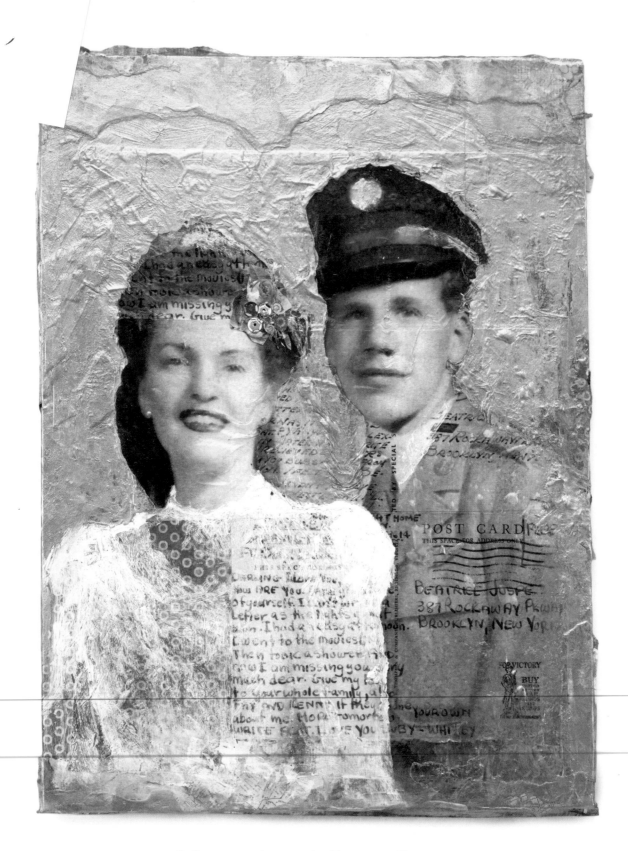

Memories: A Love Story

Am I Finished?

"If you ask me what I came to do in this world, I, an artist,
will answer you: I am here to live out loud."
—ÉMILE ZOLA

Hanging your completed artwork on the wall is certainly an achievement you will celebrate, but it is only a single moment. Bear in mind that creativity is an ongoing journey, not a destination. Releasing your authentic self-expression is the goal that you'll achieve as you allow yourself the freedom to create. However, it's only natural to enjoy a sense of completion with a work—that feeling of achieving a milestone—when you have spent time and energy on your canvas. So at some point, you will inevitably ask yourself, "How do I know when my painting is done? Am I finished yet?" To get to "finished," you will need to consider what "being done" really means, and why it is important to you. Your answers will help you decide if you are nearing completion, or if you are butting up against avoidance.

In our achievement-oriented society, gold stars are awarded for closure. From finishing evening homework and a sports game won or lost, to a semester in university completed or a work deadline met, completion is a strong, recurring theme. The idea heavily colors our experience and influences us to arrive at the endgame as fast and furiously as possible. But in that furious pace, you may miss the chance to weigh and consider the possibilities of a new beginning and the deep personal growth that can occur within the heart of any undertaking.

This "the-faster-the-better" attitude does not lend itself well to the artist who dares to create a bigger and more colorful, purposeful life. Authentic living

MATERIALS:

Canvas board or wood panel (size of your choice)

Black-and-white photocopy of a photo portrait of a person(s) that you care about. This photocopy should be the same size as your canvas.

Photocopies of memorabilia, such as old letters, postcards, tickets, certificates, photos, or other items that are meaningful and remind you of the person(s) in the photo (You may also use the actual objects instead of photocopies.)

Assorted paintbrushes

Liquitex Acrylic Gloss Medium and Vanish

Warm water in sink or tray large enough to fit your photocopied portrait

Dry rag or paper towel

Patterned colored papers

Scissors

Ruler

Acrylic paint in colors of your choice (I used white and gold.)

Palette

Optional: Sequins, magazine pictures, photocopies of flowers, or anything you'd like to use as embellishment

challenges that nonstop achievement mode and beckons you to slow down, absorb the profound beauty of existence, and realize that as long as you are breathing, there is no true finish line. The artwork that matters most—the canvas of your life—is a combination of your precious experiences and memories, your joys and your sorrows, and the actions you take to consciously create a life that you love with all of your heart.

Dig deep and ask yourself where your true motivation lies in "being done." Why are you asking this question now? Are you in a race to the finish line? Are you afraid to share more of yourself? Do you long to continue, yet feel you must close the door on this piece before moving on to something else? Is your inner perfectionist pushing you to conclude before you mess up what you have worked so hard to create? Are you worried about what other people will think?

Or, conversely, have you poured the fullness of your inner world onto the canvas? Did you allow your vulnerable heart and soul, your deepest longings and your wildest dreams, to have a voice through the dance of your brushstrokes? Have you allowed your inner wild to roar your own song while expressing the most authentic, unique version of the only "you" that there is? Does what you see fulfill you?

Mark by mark, your artwork has the potential to evolve into an honest, visual representation of

Let your creativity link your past and your future.

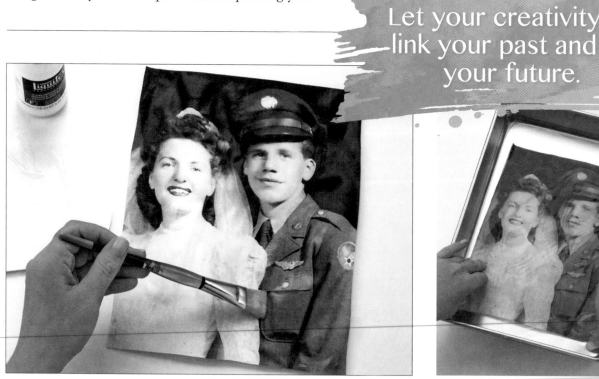

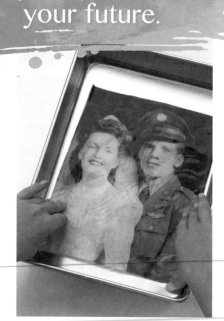

1 Have a photocopy made of a portrait you would like to use in your artwork. With a medium or large paintbrush, apply a thin layer of Liquitex Gloss Medium and Varnish over the entire front of your photocopy. Let this dry for at least 3 hours. Repeat this step twice more. After applying the last coat of gloss, allow it to dry overnight.

2 In a sink or in a small tray, submerge your fully-dry glossed photocopy portrait in warm water, and let it soak for 10–15 minutes.

your unique inner world, one that communicates something about yourself. Through your paint on canvas, you create a window into your being that can be seen and understood, first by your own self and then by the world around you.

Instead of questioning if you are finished, ask yourself, "Am I fulfilled by the choices I am making and the life I am leading? Have I been true to myself, have I chosen to be courageous and bold? Am I being, saying, expressing, and creating in alignment with my deepest truth? Am I sharing the honest expression of who I am and who I want to be?" If your answer is "yes," then not only are you *not finished*, you have just begun on a path that promises to rain rewards on you. When you are able to answer a resounding "yes!"

to many of these questions, you will not ever *want* to be done, for it is the profound and miraculous process of creativity that you will have grown to love. This is what is means to release your creativity and be the artist of your life. The reward handed to you is the masterpiece of a life that you have created, the lives you have touched, and the legacy you leave for the people you love long after you are gone. Whether your painting is finished or not, whether it expresses a unique aspect of the real "you" in a way that satisfies you, is a decision that only you—a true artist—can make. But as you begin this last project, think less about "finishing" and savor the freedom that comes with new beginnings and carving your legacy. This is how I approached *Memories: A Love Story.*

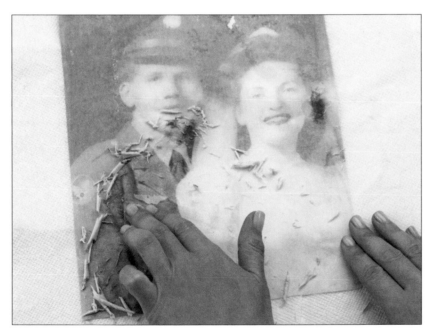

3 Remove your glossed photo from the water and place it picture side down onto a large, dry rag or fresh, dry paper towel. While still wet, use your fingers to gently rub the photocopy paper off in upward, downward, and side-to-side motions. As you rub the paper, you will begin to see your transferred image printed on a thin layer of transparent plastic, which is the dried gloss medium. Once all of the paper is peeled off, lay the image transfer flat and let it dry for at least 10 minutes. When it is fully dry, place image transfer in between heavy books to flatten it out.

IMAGE TRANSFERS: MEMORIES MAKE ART

Image transfers allow you to transform photos into sheets of transparent plastic, making it easy to incorporate the photos in your art and express yourself in symbolic and meaningful ways. You can create artwork that serves as blessed memories of the faces and places that have a special place in your heart.

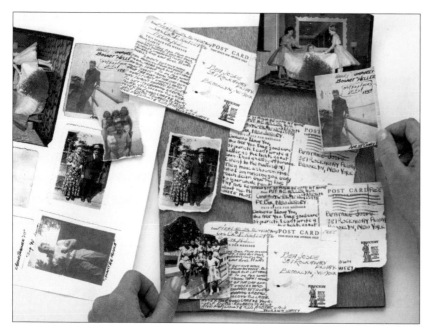

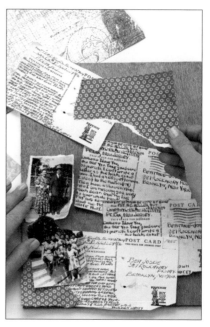

4 Using your photocopies of memorabilia, experiment with various arrangements and placements on your canvas or wood panel. If necessary, rip or cut the images into manageable pieces so they are easier to handle. In my artwork, I used photocopies of the love-letter postcards my grandfather wrote to my grandmother during his army service in the 1940s.

5 Add at least one or two colored, patterned papers to your memorabilia. Repeat step 4 as you continue to explore compositions. Do not glue anything down yet.

The Couple Atop the Wedding Cake

Using photographs in your artwork allows you to creatively explore your most significant relationships. Who are the people that inspire your spirit and encourage you to become the greatest version of yourself? For me, it is my grandparents. Their love story began when they met at ages fifteen and eighteen, and the photo transfer in my artwork is their teenage wedding picture. Throughout the nearly seventy years that they held hands and hearts through marriage, everyone who knew them declared, "Beatty and Harold are the bride and groom on top of the wedding cake!" From Brooklyn, New York, to adventures around the globe, strangers, friends, and especially family were magnetically drawn to their laughter, affection, aliveness, and more than anything, their love.

My grandparents created an everlasting masterpiece based on what matters most: meaningful lives that touched one another and the people in their orbit. Even beyond the paintings we create on canvas, nothing has more value than the loving legacy that we engrave into this world with a life well lived.

My grandmother continues her vibrant, fulfilling life, and she is one of my best friends and greatest heroes. My grandfather was one of the most talented artists I have ever met, for he left his unique, expressive mark on the canvas of my soul. Just like the famous paintings that take on lives of their own long after the artist has passed, so too are the life canvases of those we love and cherish the most.

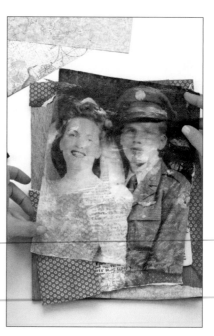

6 Place your dry image photo transfer on top of your memorabilia and colored patterned papers. Continue to repeat steps 4–5 underneath your image transfer until you are happy with the arrangement you've created.

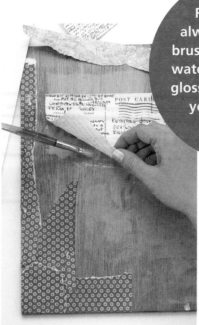

Remember to always clean your brush with soap and water to remove the gloss immediately or your brush will be ruined!

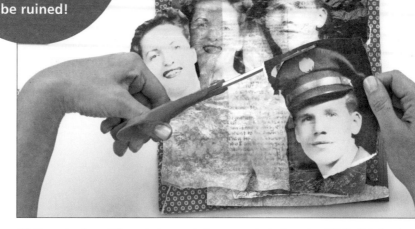

7 Place your image transfer to the side and glue your memorabilia and patterned papers to your canvas or wood panel by applying gloss medium to the back of each piece with a paintbrush. Smooth each piece with your fingers.

8 Try out a few different placments for your photo transfer. While it is in place, but before gluing it down, decide if you want your portrait to be transparent or if you prefer the faces to be opaque. (You will not see memorabilia through the faces if they are opaque.) If you would like the faces to be opaque (as I did), cut out the faces from your additional portrait photocopy.

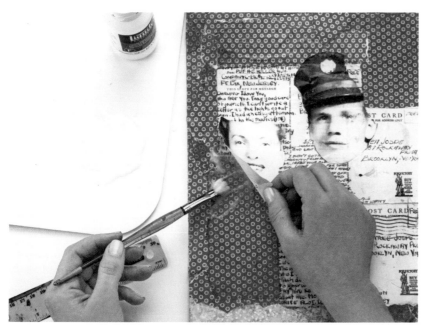

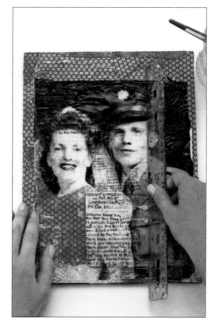

9 Glue down the photocopied faces with your gloss medium and use your fingers to smooth out bumps. Carefully align the photo transfer directly on top of the photocopied image. Using your fingers or a paintbrush, apply gloss medium to the back of your photo transfer, then glue it directly on top of your memorabilia and your photocopied portrait, if using.

10 Once glued down, run the straight edge of a ruler on top of your glued photo transfer from top to bottom and side to side to smooth out any bumps in the plastic. Remaining bumps will become interesting texture once paint is added. Let this dry.

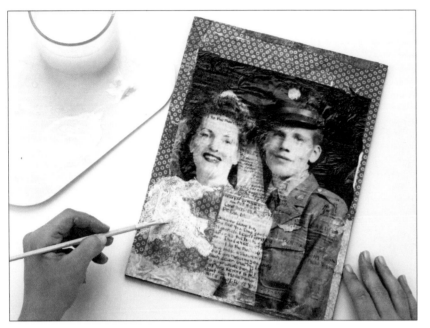

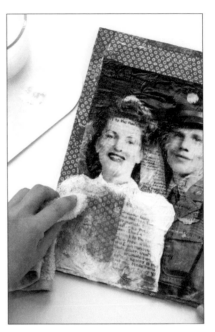

11 Apply two dollops of white acrylic paint or another color of your choice to your palette. Dip your paintbrush into water and add at least six drops of water to one dollop of paint. Mix the water and paint together to create a thin, watery paint texture. With a small- or medium-sized paintbrush, apply your watered-down paint onto the photo transfer in selected areas of your choice. As you rub and dab the thin paint with a rag, you will see the layers of memorabilia showing through both the thin paint and the photo transfer.

12 Now apply thicker paint in selected areas. Use a rag to massage the paint into the surface or slightly rub some of the paint off.

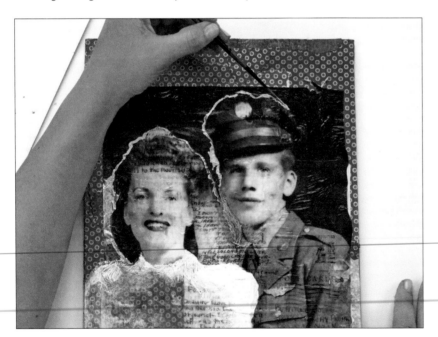

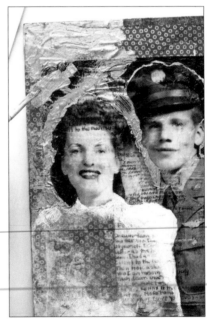

13 Place another acrylic paint color onto your palette for your background color. (I chose gold.) Create two textures of the paint again as you did in step 11. With a skinny paintbrush, outline your portrait slowly and carefully with the new paint color, using either the watered-down paint or the regularly textured paint. Be sure to maintain the curved details of hair, clothing, hats and facial contours.

14 Apply paint to selected areas of your background, alternating between regular textured paint and watered-down paint. Wherever you would like the memorabilia and patterns to show through, use the watered-down paint and your rag.

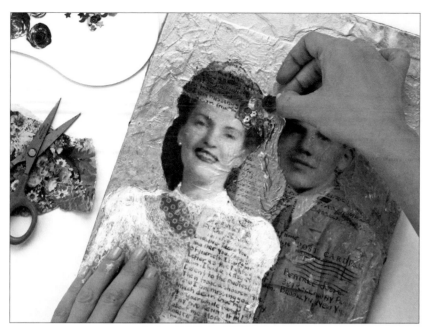

15 Add any additional embellishments such as paint, collaged flowers, or sequins. I added tiny specs of paint with the back end of my paintbrush to create earrings, and I collaged cutout flowers from a magazine and sequins as a colorful accessory.

16 Step back from your portrait and admire the faces of the ones you love. Determine if there is anything else you would like to add as final touches or if it is just right as it is.

ART & SOUL Homework

Reflect on what you have learned, how you have grown through your creative journey, and your responses to questions posed in this chapter. How has creativity enhanced your life? What reminders do you want to give yourself about being the artist of your life? What legacy do you want to leave? With pen and paper, write a love letter to yourself. Congratulate yourself on the creative risks you are taking, the new perspectives you are exploring, and the goals you are courageously pursuing in your life. Be sure to highlight your new successes, reflect on the positive, and provide nurturing reminders to yourself about who you are, your most sacred dreams, and the life you are meant to live. Place this in a stamped, sealed envelope addressed to yourself. Ask a trusted friend to keep it in a safe place, and send it to you in six to eight months' time.

Index

Aknowledgements

I would like to express my gratitude to the people who supported, inspired, and encouraged me through the fulfilling journey of creating this book. The dream of writing a book has been a line on my professional bucket list for many years. Imagine my surprise when I received an inquiry from Mixed Media Resources regarding my interest in writing a book about my *raison d'etre*—creativity and authentic self-expression! I am forever grateful to my editor, Laura Cooke, for reaching out to me, for her guidance every step of the way, and for her editing expertise. My gratitude goes to Joan Krellenstein for supporting this project from the very start and for her enthusiasm, excitement, and masterful editing of the final leg of my writing journey. Thank you to publisher Carrie Kilmer for her overall encouragement and belief in the success of this book. A tremendous thank you is due to Irene Ledwith, art director extraordinaire, for her tireless efforts in directing the hundreds of photos and the steps of each art project, as well as beautifully piecing together the entire design for this book. I extend my heartfelt appreciation to expert photographer Marcus Tullis, for his long

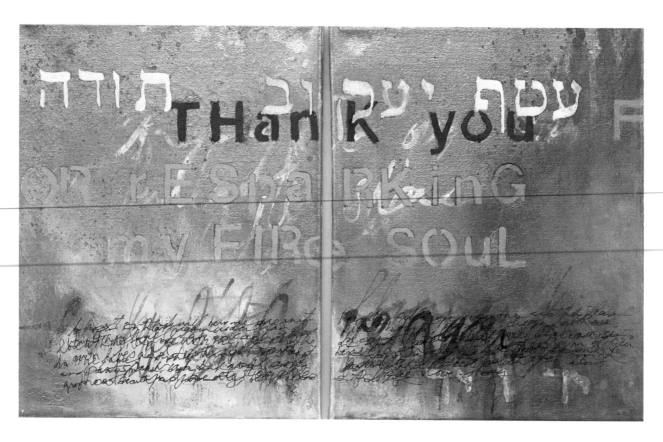

days behind the camera lens while capturing the perfect shots of this artist creating her artwork.

I am grateful to every single staff member, art instructor, supporter, and student of The Art Studio NY, the river that runs through it all. For twelve years, this studio has been my anchor, my sanctuary, my place to shine, and for this I am forever thankful. Special thanks to Richard G., Michelle R., Jake P., Michelle A., Kristy C., Sheeri A., Katiri H., and Heidi M. for overseeing our busy art studio while I escaped into the woods to write all summer long. To the talented art instructors of The Art Studio NY—too many to name—thank you for inspiring our students to express their inner truth. I extend deep gratitude to my mentor, Dr. Gordon Ball, who taught me how to feel the fear and do it anyway while running toward all that I desire.

Thank you to my entire family and dear friends, of which there are too many to name, yet you know who you are. Your unconditional love and support mean the world to me, and you nurture me to make the canvas of my life a living masterpiece. Last, but not least, thank You to the ultimate Creator for the creative gifts that You have awakened within me.

Resources

ART CLASSES AND FREE ONLINE ART VIDEOS

The Art Studio NY (www.TheArtStudioNY.com)
145 West 96 Street, #1b
New York, NY 10025
(212) 932-8484

ART SUPPLY STORES

Utrecht Art Supplies
(www.UtrechtArt.com)
1-800-223-9132
45 retail locations throughout the US

Blick Art Materials
(www.DickBlick.com)
1-888-953-9848
65 retail locations throughout the US

Cheap Joe's Art Stuff
(www.CheapJoes.com)
1-888-266-4732
Online retailer

Michaels Arts & Crafts
(www.Michaels.com)
1-800-642-4235
More than 1,000 retail locations
throughout the US

Jerry's Artarama
(www.JerrysArtarama.com)
1-800-827-8478
17 retail locations in the US

INSPIRING BOOKS

Life, Paint and Passion: Reclaiming The Magic of Spontaneous Expression by Michele Cassou and Stewart Cubley (TarcherPerigee, 1996)

The Artist's Way: A Spiritual Path to Higher Creativity by Julia Cameron (Jeremy P. Tarcher, 1992)

Daring Greatly: How the Courage to Be Vulnerable Transforms the Way We Live, Love, Parent and Lead by Brene Brown (Avery, 2015)

I Will Not Die an Unlived Life: Reclaiming Purpose and Passion by Dawna Markova, (Conari Press, 2000)

Letters to a Young Poet by Rainer Maria Rilke (W. W. Norton & Company; 1993

The Art Spirit by Robert Henri (Icon Editions; Westview Press, 1984)